DRAWING
CUTE BIRDS
in Colored Pencil

Ai Akikusa

Brimming with creative inspiration, how-to projects, and useful information to enrich your everyday life, Quarto Knows is a favorite destination for those pursuing their interests and passions. Visit our site and dig deeper with our books into your area of interest: Quarto Creates, Quarto Cooks, Quarto Homes, Quarto Lives, Quarto Drives, Quarto Explores, Quarto Gifts, or Quarto Kids.

Original Japanese title: Iroenpitsu de kawaii toritachi
Originally published in Japan by PIE International in 2015

PIE International
2-32-4 Minami-Otsuka, Toshima-ku, Tokyo 170-0005 JAPAN
© 2015 Ai Akikusa / PIE International

First published in the United States of America in 2016 by
Quarry Books, an imprint of The Quarto Group,
100 Cummings Center, Suite 265-D, Beverly, MA 01915, USA.
T (978) 282-9590 F (978) 283-2742
QuartoKnows.com

Quarry Books titles are also available at discount for retail, wholesale, promotional, and bulk purchase. For details, contact the Special Sales Manager by email at specialsales@quarto.com or by mail at The Quarto Group, Attn: Special Sales Manager, 401 Second Avenue North, Suite 310, Minneapolis, MN 55401, USA.

10 9 8 7 6 5 4

ISBN: 978-1-63159-265-2

10 9 8 7 6 5 4

Author: Ai Akikusa
English Translation: Allison Markin Powell
Art Director: Shun-ichi Miki
Designer: Itsuko Kira (Bunkyo Zuanshitsu)
Editors: Kayako Nezu + Akiko Taki (Daifuku Shorin)

Printed in China

INTRODUCTION

I've loved birds since I was a child. The many parrots and parakeets at our house were my earliest non-human friends. I like watching the sparrows in our yard, and when I venture into the woods and forests slightly outside of the city, I enjoy hearing birds' songs and sensing them all around me. And at the zoo, I encounter all sorts of interesting birds from around the world, such as penguins and shoebills.

In this book, I introduce ways of drawing different kinds of birds. I've included how to draw characteristic features or to bring out the texture of the feathers, as well as various hints about how to draw each bird. But I'm not suggesting that you have to draw birds exactly my way. Feel free to draw whatever birds you like, using whatever colored pencils you like—it's all up to you!

When you discover a bird that interests you, part of the fun is to learn about its eggs and chicks, its songs, what it eats, and where it lives. When you draw the fast-running ostrich, it's even more fun when you can sense the strength of its powerful legs. You can be dazzled by the beautiful plumage of a brightly colored bird as you learn more about how to draw the birds that catch your fancy.

There are lots of different kinds of birds in these pages, and I hope you will discover many new favorites.

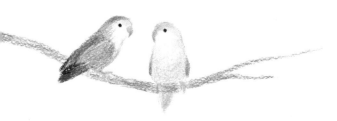

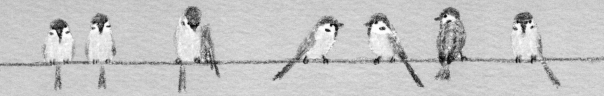

part 1

Looking at Familiar Birds We Already Know

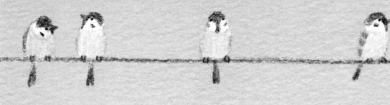

part 2

Birds We Might Like to Know More About

part 3

Brightly Colored Birds

THE COLORS USED IN THIS BOOK

These are the colors that I used to draw the birds in this book. Even with birds that look black or brown, if you look more closely, you will see that their feathers contain various colors. The colored pencils I use are Holbein Artist Colored Pencils. There is no need to use the same pencils. It's just as much fun to use similar colors that you find on your own, or mix colors to make new shades and tones.

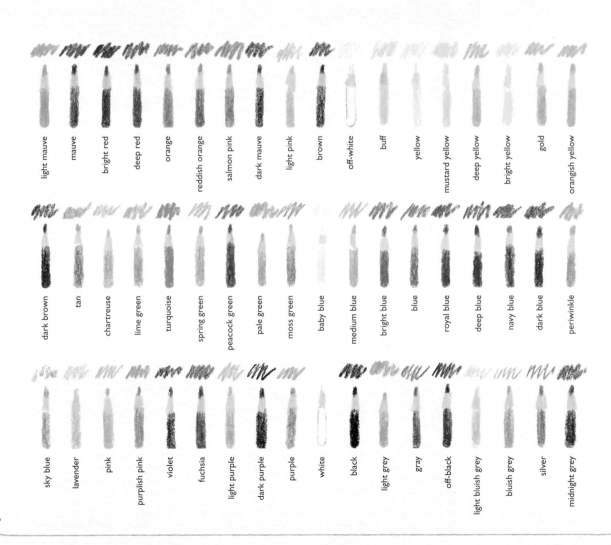

light mauve · mauve · bright red · deep red · orange · reddish orange · salmon pink · dark mauve · light pink · brown · off-white · buff · yellow · mustard yellow · deep yellow · bright yellow · gold · orangish yellow

dark brown · tan · chartreuse · lime green · turquoise · spring green · peacock green · pale green · moss green · baby blue · medium blue · bright blue · blue · royal blue · deep blue · navy blue · dark blue · periwinkle

sky blue · lavender · pink · purplish pink · violet · fuchsia · light purple · dark purple · purple · white · black · light grey · gray · off-black · light bluish grey · bluish grey · silver · midnight grey

DRAWING DIFFERENT TEXTURES OF FEATHERS

It's not just about distinguishing different colors—drawing various textures of feathers brings out various features. They might be on the same bird, but depending on where they grow, the feathers on its head, breast, or wings might be larger or look different. Try to make your birds look like you can touch them.

Most chicks have soft and fluffy down feathers.

Their feathers grow in tight and stubbly.

Clusters of slender, tightly packed feathers. They seem soft, like they hold a lot of air.

Test Out Different Colors

Find out what color is produced when you layer one color over another. Use scraps of paper to practice on.

Clusters of short, round feathers. They almost look like scales.

Large, separate feathers. Mostly found on wings and the tail.

LEARNING ABOUT BIRD ANATOMY

To understand how birds' bodies work, it's easier to compare them with human bodies.

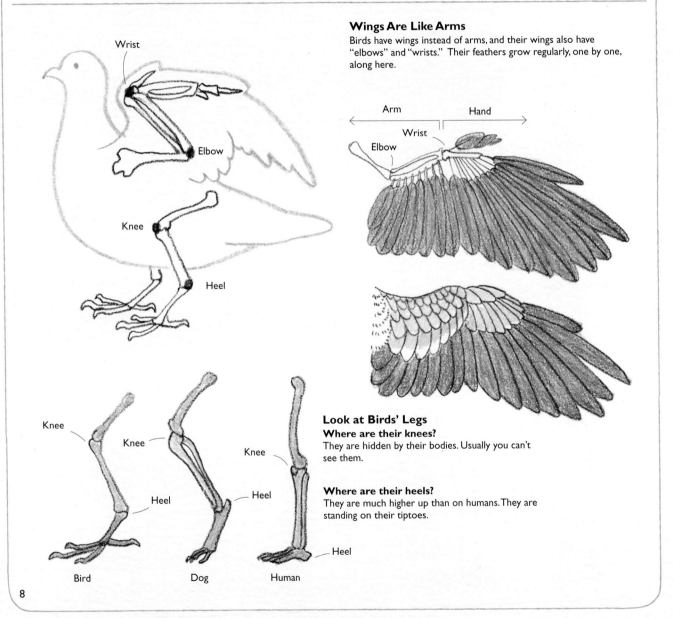

Wings Are Like Arms

Birds have wings instead of arms, and their wings also have "elbows" and "wrists." Their feathers grow regularly, one by one, along here.

Look at Birds' Legs

Where are their knees?

They are hidden by their bodies. Usually you can't see them.

Where are their heels?

They are much higher up than on humans. They are standing on their tiptoes.

Differences in Beaks and Bills

For tearing up meat, catching insects, feeding their young, catching fish in water, making holes in trees…all birds have different beaks and bills based on where they live and what they eat. They have each developed the beak or bill that best suits their needs.

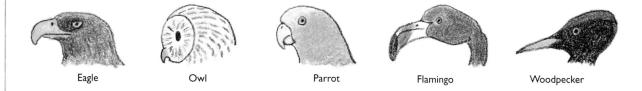

| Eagle | Owl | Parrot | Flamingo | Woodpecker |

Differences in Feet

Some have "claws" for perching securely on tree branches, others have "talons" for catching prey with their feet, and others have "webbing" for swimming—the shape of a bird's feet also depends on how and where it lives. Most birds have three toes in front and one toe in back, but parrots have two toes each in front and back, and ostriches have only two toes.

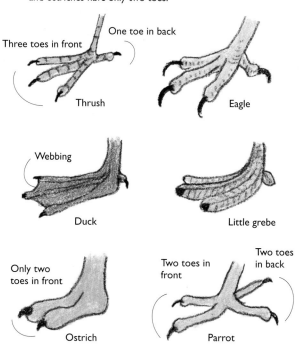

Differences in Males and Females

It's common for males and females of the same species to be different colors. Generally, the more colorful and ornamented ones are the males. This is so they can show off and attract females during mating season. There are exceptions where the females are more flamboyant (p. 62–63).

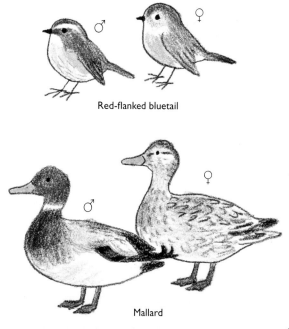

Red-flanked bluetail

Mallard

part

LOOKING AT FAMILIAR BIRDS WE ALREADY KNOW

Let's take a closer look at the birds we're already familiar with: the sparrows, pigeons, and crows we see in the city, the small wild birds we might catch a glimpse of in the mountains or the woods, and the chickens and ducks that have lived amongst us since long ago. Hear their calls, watch their behavior… how many discoveries will you make?

SPARROW

Sparrows are the basic form we'll use for drawing small birds. There are lots of them near and around houses, so take a look at their shape and movement.

Species order and family: *Passeriformes, Passeridae*

Size: 5.5–6 in (14–15 cm)

Their habitat is widespread from Europe to Asia. In Japan, they can be found all over the country, from Hokkaido to Okinawa.

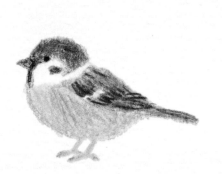

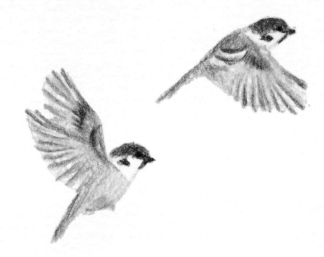

Sparrow's body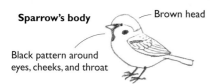

Brown head

Black pattern around eyes, cheeks, and throat

Colored pencils used for sparrow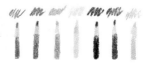

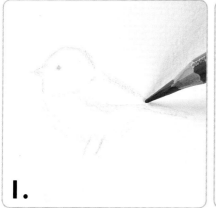

1.

Using gray, roughly sketch the shape of the entire body. Press lightly so that you won't be able to see these lines when you add in the rest of the colors.

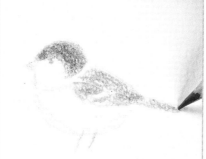

2.

Color the dark part of the head with brown and with tan, draw the back, the wing, then the tail. Coloring in softly makes them look cute.

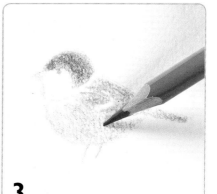

3.

Press lightly with buff, bluish gray, and tan to softly color in the belly.

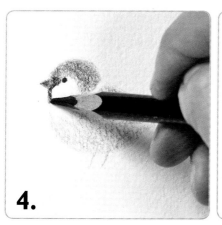

4.

With your black pencil, draw the eye, beak, and pattern on the face, paying close attention to the position of the beak and the eye.

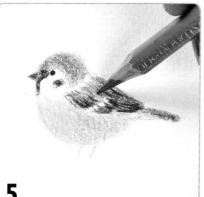

5.

Draw the pattern on the cheek with black. Using brown, color in the lower part of the wing and the tail. Draw the feathers over this with dark brown.

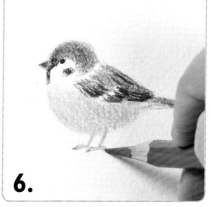

6.

The legs and feet should be drawn with light pink, and then add claws with the gray pencil.

13

BIRD-WATCHING NOTES—FAMILIAR BIRDS

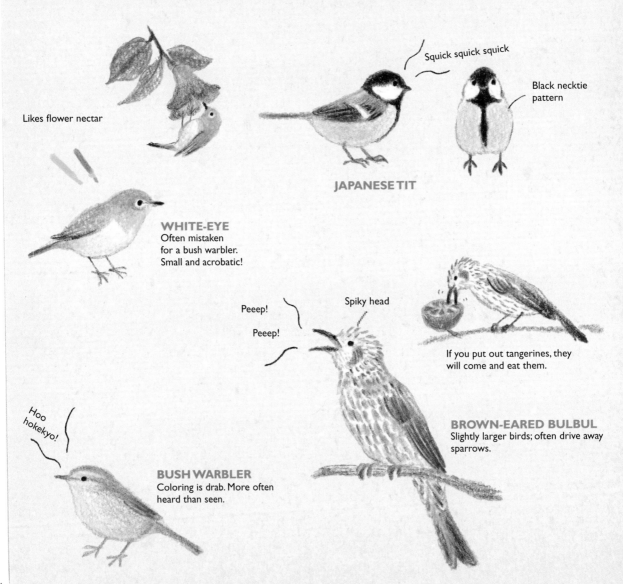

Likes flower nectar

Squick squick squick

Black necktie pattern

JAPANESE TIT

WHITE-EYE
Often mistaken for a bush warbler. Small and acrobatic!

Peeep!

Peeep!

Spiky head

If you put out tangerines, they will come and eat them.

Hoo hokekyo!

BROWN-EARED BULBUL
Slightly larger birds; often drive away sparrows.

BUSH WARBLER
Coloring is drab. More often heard than seen.

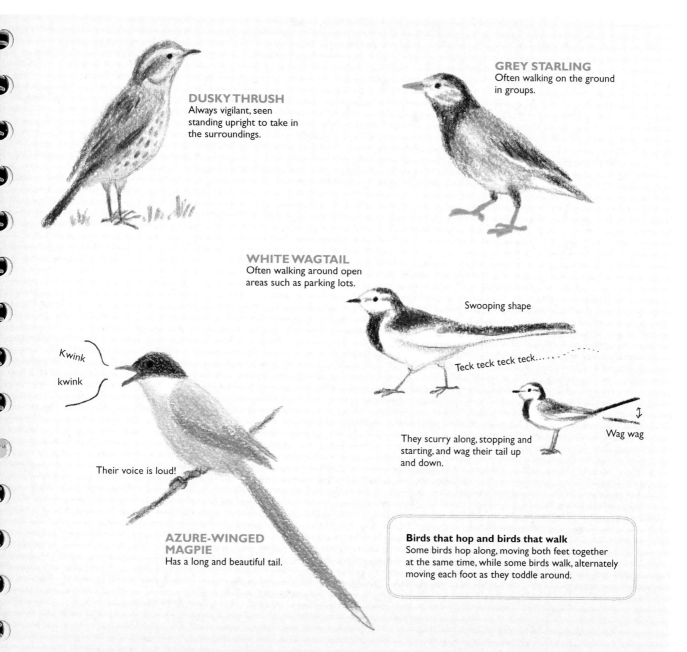

DUSKY THRUSH
Always vigilant, seen standing upright to take in the surroundings.

GREY STARLING
Often walking on the ground in groups.

WHITE WAGTAIL
Often walking around open areas such as parking lots.

Swooping shape

Teck teck teck teck......

Kwink

kwink

Their voice is loud!

They scurry along, stopping and starting, and wag their tail up and down.

Wag wag

AZURE-WINGED MAGPIE
Has a long and beautiful tail.

Birds that hop and birds that walk
Some birds hop along, moving both feet together at the same time, while some birds walk, alternately moving each foot as they toddle around.

15

JAPANESE TIT AND OTHER SMALL BIRDS

Species order and family: *Passeriformes, Paridae*
Size: 5–6.3 in (13–16 cm)
Lives in mountains and forests, as well as urban parks.

Colored pencils used for Japanese tit

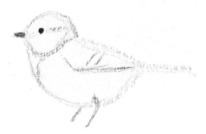

1. Sketch the shape of the entire body in gray. With the black pencil, draw the eye.

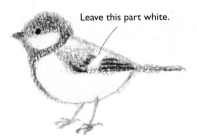

Leave this part white.

2. In black, draw the pattern that extends from the head to the belly. Lightly color in the wing using dark blue, filling in the top part with black. The legs and feet can be drawn in gray.

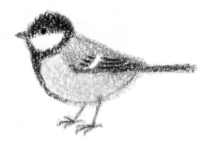

3. Layer the coloring on the head using dark blue. Color in the back using chartreuse, adding gradation to the blue parts. The belly can be filled in with light gray and off-white.

VARIED TIT

Species order and family: *Passeriformes, Paridae*
Size: 5–6 in (13–15 cm)
Lives in forests. Body appears slightly larger than a Japanese tit.

Colored pencils used for varied tit

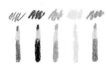

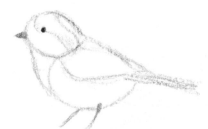

1. Using gray, sketch the shape of the entire body, and with black, draw the eye.

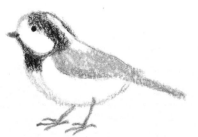

2. Draw the pattern on the head and throat in black. Then, with your periwinkle pencil, color in the wing. The legs and feet should be drawn in gray.

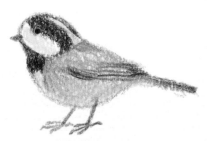

3. Fill in the blank parts on the face, head, and chest using mustard yellow. Next, using reddish orange, color in the belly and back. Layer the coloring on the belly using mustard yellow.

LONG-TAILED TIT

Species order and family: *Passeriformes, Aegithalidae*
Size: 4.8–6 in (12–15 cm)
Lives in the woods. Not including the tail, the size of the body is
smaller than a sparrow's.

Colored pencils used for long-tailed tit

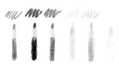

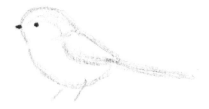

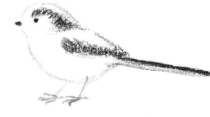

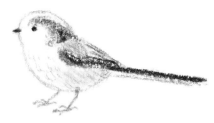

1. Sketch the shape of the entire body in
your gray pencil, and with black, draw
the eye and beak.

2. Still using your black pencil, draw the
pattern on the head, and color in the
edges of the wing and tail. Switching to
gray, draw the legs and feet.

3. Add a touch of dark mauve above the
eye and, using the same pencil, lightly
color in below the belly. Layer the
coloring on the back and belly with buff.
Now with bluish gray, draw the feathers
on the chest. Lastly, fill in the blank areas
with white.

EURASIAN BLUE TIT

Species order and family: *Passeriformes, Paridae*
Size: 4.3 in (11 cm)
A beautiful bird from Europe with blue and yellow plumage.

Colored pencils used for Eurasian blue tit

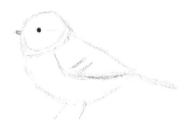

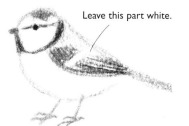

Leave this part white.

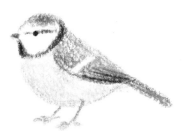

1. With your gray pencil, sketch the
shape of the entire body. Using black,
draw the eye.

2. Color in the top of the head, the wing, and the
tail with bright blue. Draw the lines on either
side of the eye, as well as the pattern on the
neck and chin, using bright blue before layering
over it with black. Still using black, draw the
feathers on the lower part of the wing. Switch
to gray to draw the legs and feet.

3. Color in the back and belly with
bright yellow. Add gradations of
color on the back with chartreuse.
Fill in the blank parts of the face
with white.

17

CUTE SMALL BIRDS FROM AROUND THE WORLD

GOLDCREST
Size: 4 in (10 cm)
Tiny! The top of its
head looks like a yellow
chrysanthemum.

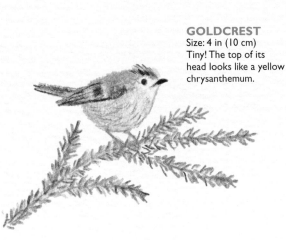

**RED-FLANKED
BLUETAIL**
Size: 5.5 in (14 cm)
The male is a slightly dusky
blue—gorgeous.

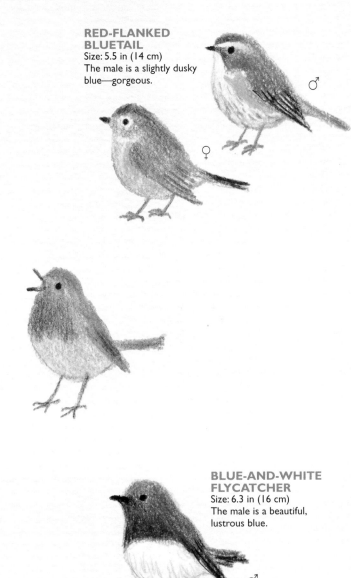

EUROPEAN ROBIN
Size: 4.9–5.5 in (12.5–14 cm)
Small bird found throughout
England. Appears often in
folktales.

DAURIAN REDSTART
Size: 5.3–6.1 in (13.5–15.5 cm)
A familiar winter resident in
Japan.

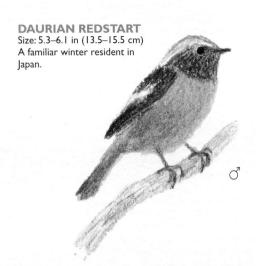

**BLUE-AND-WHITE
FLYCATCHER**
Size: 6.3 in (16 cm)
The male is a beautiful,
lustrous blue.

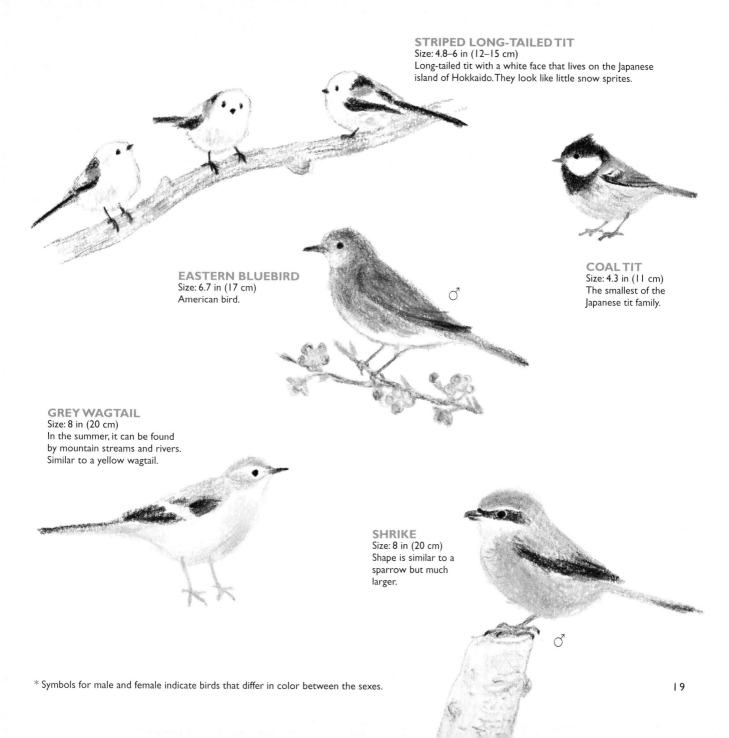

STRIPED LONG-TAILED TIT
Size: 4.8–6 in (12–15 cm)
Long-tailed tit with a white face that lives on the Japanese island of Hokkaido. They look like little snow sprites.

COAL TIT
Size: 4.3 in (11 cm)
The smallest of the Japanese tit family.

EASTERN BLUEBIRD
Size: 6.7 in (17 cm)
American bird.

♂

GREY WAGTAIL
Size: 8 in (20 cm)
In the summer, it can be found by mountain streams and rivers. Similar to a yellow wagtail.

SHRIKE
Size: 8 in (20 cm)
Shape is similar to a sparrow but much larger.

♂

* Symbols for male and female indicate birds that differ in color between the sexes.

SWALLOW

You can distinguish the swallow by the distinctive shape of its tail. In Europe, swallows are said to signify happiness. Once spring arrives, you can see them zipping around in the air.

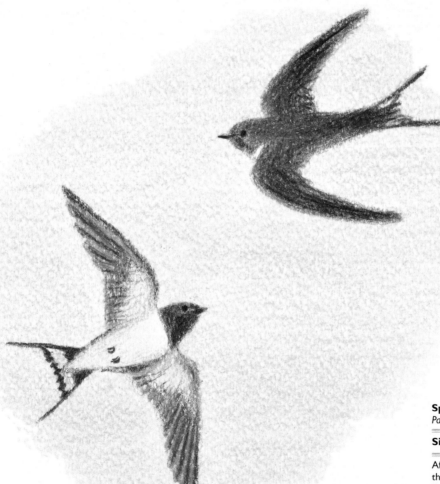

Deeply forked tail

Long wings

Red face

Swallow's body

Species order and family:
Passeriformes, Hirundinidae

Size: 6.7 in (17 cm)

After spending winters in warm climates, they arrive in Japan in springtime, where they build their nests under eaves and similar cozy places. They raise their young in pairs.

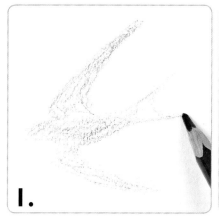

1.

Using navy blue, lightly sketch the shape of the body. The silhouette already looks like a swallow.

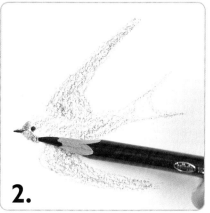

2.

Draw the eye and beak with black. Starting with dark mauve, draw the pattern on the face, and then layer over it with deep red.

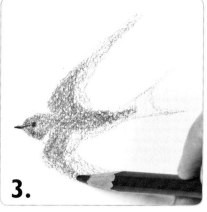

3.

Color in the shape of the body more distinctly with your navy blue pencil. Leave the chest and the end of the tail blank.

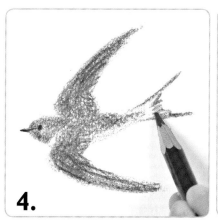

4.

With midnight gray, draw the lower parts of the wing and the end of the tail.

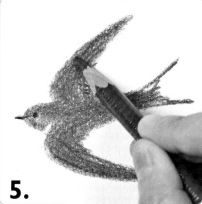

5.

Fill in the body one more time with navy blue, and then use midnight gray to layer over the dark areas once more.

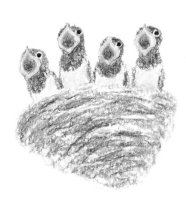

CUCKOO

They arrive in Japan every May, and their invigorating call heralds the arrival of summer.

Species order and family:
Cuculiformes, Cuculidae

Size: 13.8 in (35 cm)

They do not make their own nests, but instead lay eggs in the nests of other birds such as shrikes or reed warblers, forcing these birds to raise their young.

Cuckoo

cuckoo

This lazy lowering of the cuckoo's long wing is very typical.

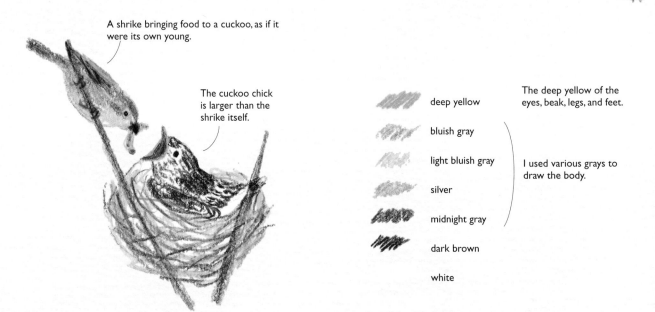

A shrike bringing food to a cuckoo, as if it were its own young.

The cuckoo chick is larger than the shrike itself.

deep yellow

bluish gray

light bluish gray

silver

midnight gray

dark brown

white

The deep yellow of the eyes, beak, legs, and feet.

I used various grays to draw the body.

CROW [Jungle crow]

Everyone thinks crows are jet black, but if you look closely, other colors are hidden in their feathers. People think crows are scary too, but take another look and see that their faces are pretty cute.

Differences between the jungle crow and the carrion crow

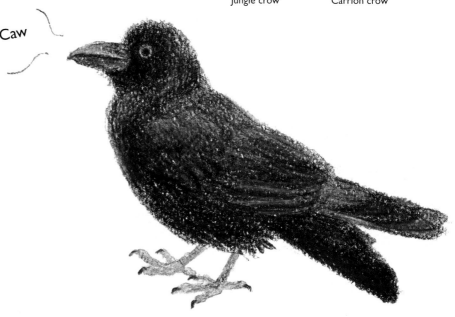

Forehead is rounded

Bill is thick

Bill is slender

Clean shape of the head

Jungle crow

Carrion crow

Caw

Species order and family:
Passeriformes, Corvidae

Size: 22 in (56 cm)

Crows most often found in Japan are either jungle crows or carrion crows. You can distinguish them by their bills and the shape of their heads.

 black

 midnight gray

 bluish gray

 light bluish gray

+

Many colors can be found in their feathers.

 dark blue

 violet

 peacock green

The eyes are outlined in gray, so when you draw the surrounding black, be sure not to cover up the charm of their eyes.

23

THE CROW FAMILY

These are birds in the crow family. Like crows, they are all very smart.

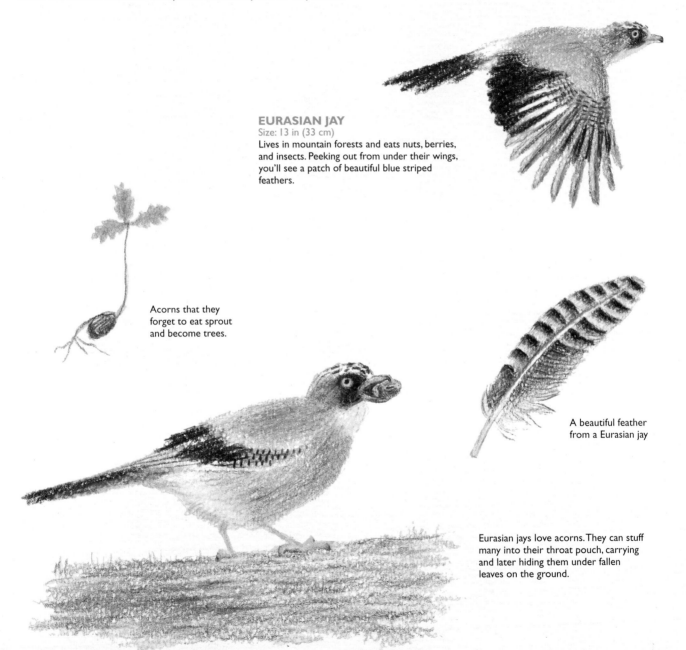

EURASIAN JAY
Size: 13 in (33 cm)
Lives in mountain forests and eats nuts, berries, and insects. Peeking out from under their wings, you'll see a patch of beautiful blue striped feathers.

Acorns that they forget to eat sprout and become trees.

A beautiful feather from a Eurasian jay

Eurasian jays love acorns. They can stuff many into their throat pouch, carrying and later hiding them under fallen leaves on the ground.

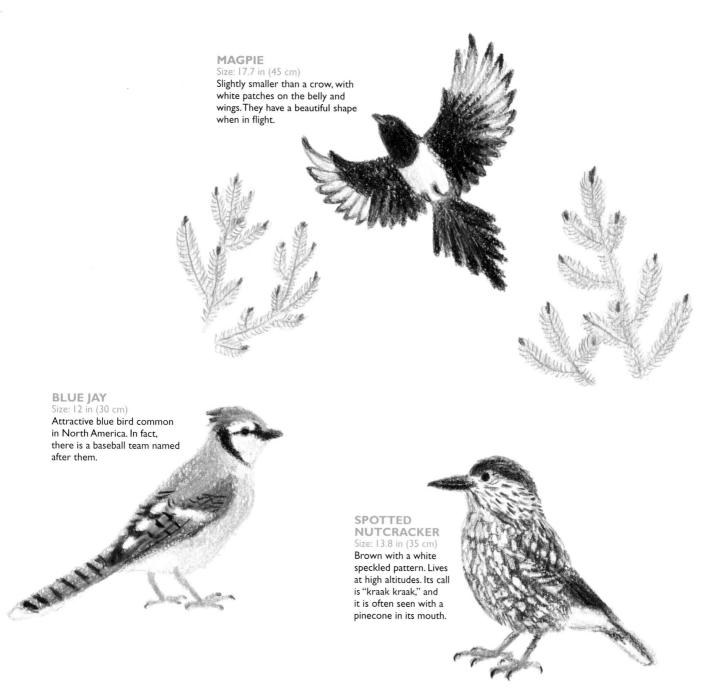

MAGPIE
Size: 17.7 in (45 cm)
Slightly smaller than a crow, with white patches on the belly and wings. They have a beautiful shape when in flight.

BLUE JAY
Size: 12 in (30 cm)
Attractive blue bird common in North America. In fact, there is a baseball team named after them.

SPOTTED NUTCRACKER
Size: 13.8 in (35 cm)
Brown with a white speckled pattern. Lives at high altitudes. Its call is "kraak kraak," and it is often seen with a pinecone in its mouth.

25

KINGFISHER

Colored pencils used for kingfisher

The kingfisher's body is similar to the sparrow, but it has a larger head and a longer beak. After drawing the feathers in pale blue, you can really bring out the pattern by layering more colors.

Species order and family:
Coraciiformes, Alcedinidae

Size: 6.7 in (17 cm)

Living near water, its diet consists of fish and water bugs. Because of their beautiful colors, they are sometimes referred to as "blue gems."

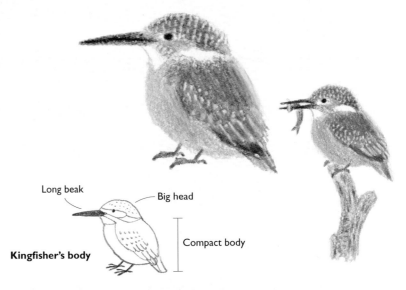

Long beak

Big head

Compact body

Kingfisher's body

1.

Lightly sketch the body, using medium blue for the head and wing, midnight gray for the beak, and black for the eye. With the salmon pink pencil, draw the pattern on the face and color in the belly.

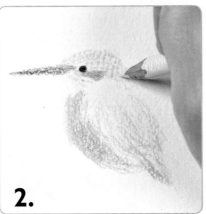

2.

In baby blue, draw the underlying dotted pattern on the head and wing. Be sure to press down firmly.

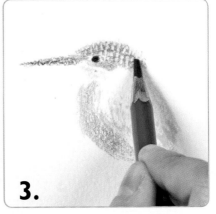

3.

Make the dotted pattern pop by lightly coloring over it with blue.

RUDDY KINGFISHER

Size: 10.6 in (27 cm)
Its entire body is red, but its beak is especially vivid.

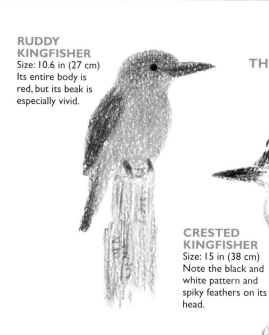

THE KINGFISHER FAMILY

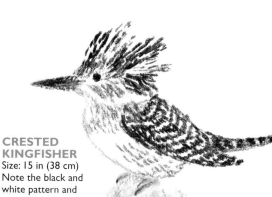

CRESTED KINGFISHER

Size: 15 in (38 cm)
Note the black and white pattern and spiky feathers on its head.

Wa ha ha ha ha ha ha!

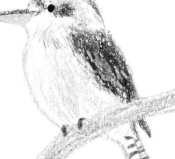

LAUGHING KOOKABURRA

Size: 15.7 in (40 cm)
This Australian bird has a call that sounds like human laughter!

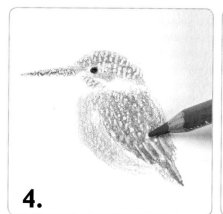

4.

Layer the coloring of the blue parts using turquoise and then layer the upper wing and undertail with midnight gray.

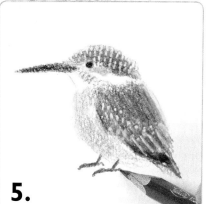

5.

Draw the legs and feet with deep red and the claws with black.

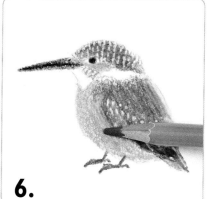

6.

Color in the belly using orangish yellow, then again with salmon pink. By layering different colors this way, you can create a sense of lightness.

Kingfisher

WOODPECKER

[Great spotted woodpecker]

They bore holes in tree trunks and make nests. Their perching habits on tree trunks are different from other birds, so pay attention when you draw the direction of their bodies and faces, as well as the position of their feet!

Great spotted woodpecker's body

Sharp beak for poking holes in trees

Firmly gripping claws

Uses tail to support perch on tree

Species order and family:
Piciformes, Picidae

Size: 9.3 in (23.5 cm)

Lives in forests and grasslands, eating insects and occasionally seeds and berries. Pecks at tree trunks with its beak to catch bugs, make mating calls, and build nests.

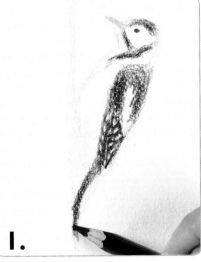

1.

Sketch the shape using bluish gray. Then with black, draw the beak and the eye. Keeping the shape of the pattern in mind, draw the head, face, wing, and tail.

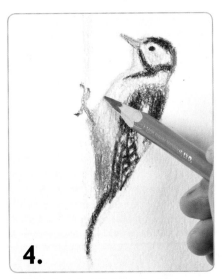

4.

Draw the belly with light, soft strokes of your bluish gray pencil. Then layer mustard yellow and tan over it.

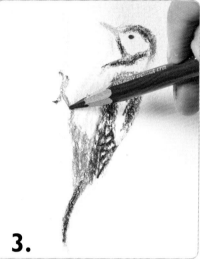

2.

Draw the pattern on the head and undertail with bright red.

3.

As you draw the legs and feet in midnight gray, pay close attention to how the legs are perched. Next, use black to draw the claws.

Colored pencils used for woodpecker

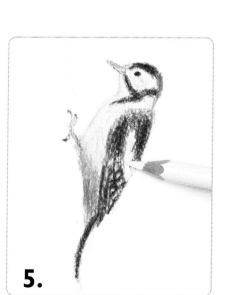

5.

Go back over the black pattern with your black pencil to clearly define the body. Finally, color in the blank parts off-white.

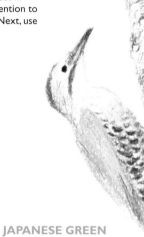

JAPANESE GREEN WOODPECKER
Size: 11.4 in (29 cm)
Slightly larger than the great spotted woodpecker, with green wings and back.

Woodpecker

PIGEON [Rock dove]

Pigeons live in large flocks, but their patterns and density of color vary greatly. You'll find many of them in urban areas.

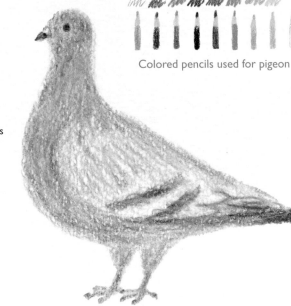

Colored pencils used for pigeon

They have a nose flap on top of the beak.

This part gleams iridescently.

Chest

Pigeon's body

Species order and family:
Columbiformes, Columbidae

Size: 13 in (33 cm)

Lives in cities where there are lots of people rather than natural environments. Has an herbivorous diet of seeds and grain, but sometimes eats insects too.

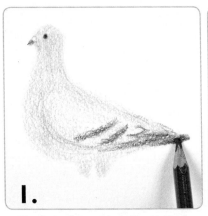

1.

Sketch the shape of the body with bluish gray, coloring in along the way. Press down lightly within the wing. Using midnight gray, draw the beak and the nose flap above it, the pattern on the wing, and the tail. With reddish orange and black, draw the eye.

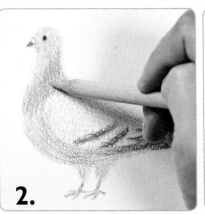

2.

Draw the feet with your fuchsia pencil, and then use it again along with turquoise to create the pattern on the neck and chest. Layer over the colors with pale green and lavender. It's easy to deepen colors by layering the lighter ones over the darker ones.

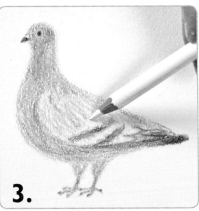

3.

The claws can be drawn with midnight gray, but switch to dark gray to roughly go back over the entire body. Lastly, color in areas on the wing with white.

30

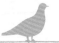

her-her-oo-oo

her-her-oo-oo

ORIENTAL TURTLE DOVE
Size: 13 in (33 cm)
Does not live in flocks and is found in residential areas. You can often hear their calls.

Sky blue for the neck

Salmon pink for the scaled pattern on the wings

WHITE-BELLIED GREEN PIGEON
Size: 13 in (33 cm)
Though it mainly lives in the woods and forests, you'll sometimes see one at the shoreline during summertime.

The gradations of color in its feathers include yellow, chartreuse, baby blue, mauve, and midnight gray.

CHICKEN

We all know what a chicken is, but here I drew a very colorful breed. By layering many colors, you'll get a deeply varied pattern. It's easiest to start by drawing the cockscomb and the beak.

Red cockscomb is bigger on the male.

Chicken's body

The male has a prominent tail.

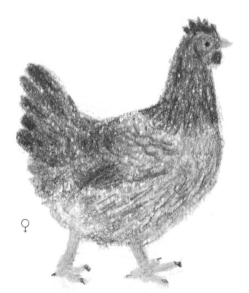

♀

♂

Species order and family:
Galliformes, Phasianidae

Size: male: 2.3 ft (70 cm) • female: 1.7 ft (50 cm)

Domesticated in warm and cold climates, chickens often appear in picture books all over the world.

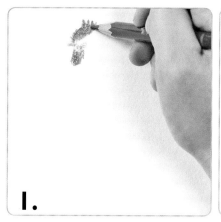

1.

Start by drawing the cockscomb in bright red and then the beak in deep yellow.

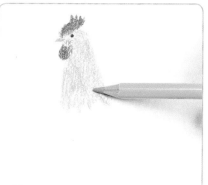

2.

Next, use black to draw the eye. With your gold pencil, create the face and neck, and then from the top, use reddish orange to quickly layer color in the direction of the wing.

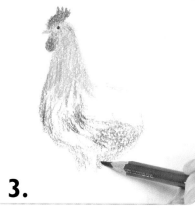

3.

Sketch the shape of the chest, undertail, and thighs in brown, coloring in as you go along. Follow in the direction that the wing would go.

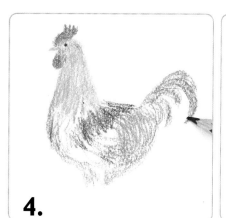

4.

Color in various parts of the body with dark mauve, dark purple, and reddish orange. Using navy blue, draw the tail.

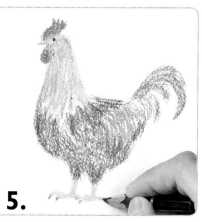

5.

Still with the navy blue pencil, color in the chest, thighs, and the lower part of the wings. Moving down, draw the feet in deep yellow and use black for the claws.

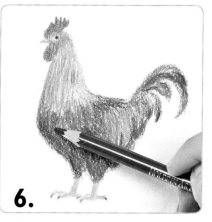

6.

Go back over everything, layering the colors. In the dark blue parts, layer with peacock green to give them a rich hue.

33

GUINEAFOWL

This distinctive African bird has a polka-dot pattern. When you finally color in the body, it's fun to watch the pattern you've drawn in white appear before your eyes.

1.

Sketch the shape of the body using off-black. With your gold, bright red, black, sky blue, and periwinkle pencils, draw the face. Make additional black lines of the wing, which the polka dots will follow. Sharpen the tip of your white pencil and use it to draw polka dots over the entire body.

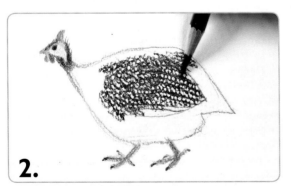

2.

Continue drawing polka dots on the wing in regular lines. Now take your black pencil and color over the dots to bring out the pattern. Finally, layer with dark brown to quickly fill in color.

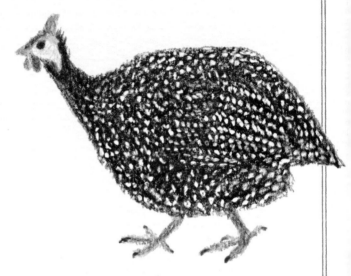

Species order and family: *Galliformes, Numididae*

Size: 20.9 in (53 cm)

Found living in groups on the grasslands or in the forests in Africa, they are often raised for food—particularly in French cuisine.

Guineafowl

Males have red crests above the eyes.

PTARMIGAN ♂
Size: 14.6 in (37 cm)
Winter plumage.

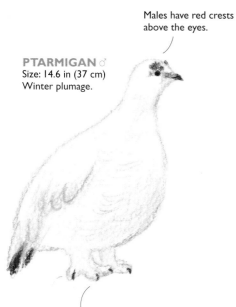

It even has feathers on its toes to keep warm.

PTARMIGAN ♀
Size: 14.6 in (37 cm)
Summer plumage.

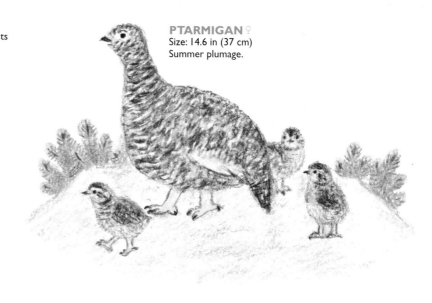

THE GAME BIRD FAMILY

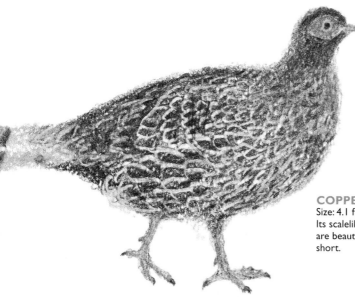

COPPER PHEASANT ♂
Size: 4.1 ft (125 cm)
Its scalelike feathers and long tail are beautiful. The female's tail is short.

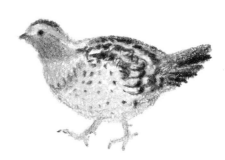

CHINESE BAMBOO PARTRIDGE
Size: 10.6 in (27 cm)
Lives in groups in groves and thickets, where it walks on the ground looking for food.

35

WILD DUCK [Mallard]

You see lots of these birds floating in the water, with their trademark rounded chests thrust out. They have webbed feet for swimming.

Species order and family:
Anseriformes, Anatidae

Size: 23 in (59 cm)

Lives in cold climates such as Siberia in summertime and arrives in Japan in the winter. Some ducks raise their young in Japan without returning to Siberia, so you might see their adorable little ducklings.

Mallard's body

Their eyes are raised slightly above the level of their bills.

White pattern like a collar at the throat

Brown chest

Green head

Curled feathers

Blue

Webbed feet (see p. 9)

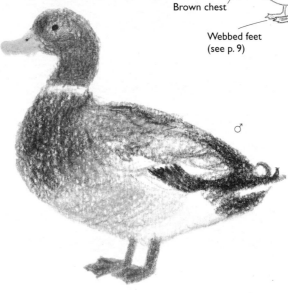

♂

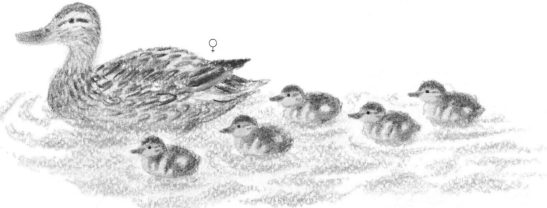

♀

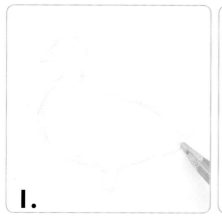

1.

Roughly sketch the shape of the body using bluish gray.

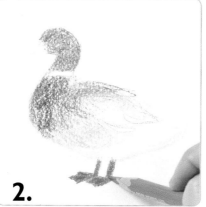

2.

With your peacock green pencil, draw the head, then use dark brown for the chest and back, bluish gray for the belly, and deep red for the legs and feet.

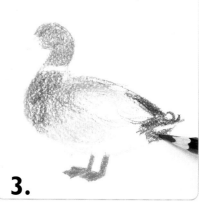

3.

Draw the tip of the undertail and the tail in black. Make sure the tips of the tail feathers curl up.

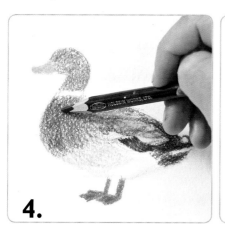

4.

The bill can be drawn with your deep yellow pencil, and then switch to dark blue and black for the pattern on the feathers. Fill in the chest and back with brown, and then quickly layer over that with dark purple.

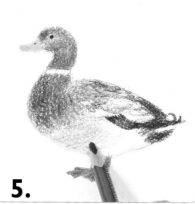

5.

Using black, draw the eye and the nostril—staying mindful of the hollow around the eye. Layer the head with peacock green and dark purple, then lightly add strokes of brown on the belly.

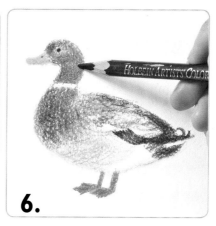

6.

Create a 3D effect by layering the color on the head with dark blue and the underside of the bill with orange.

37

Wild Duck

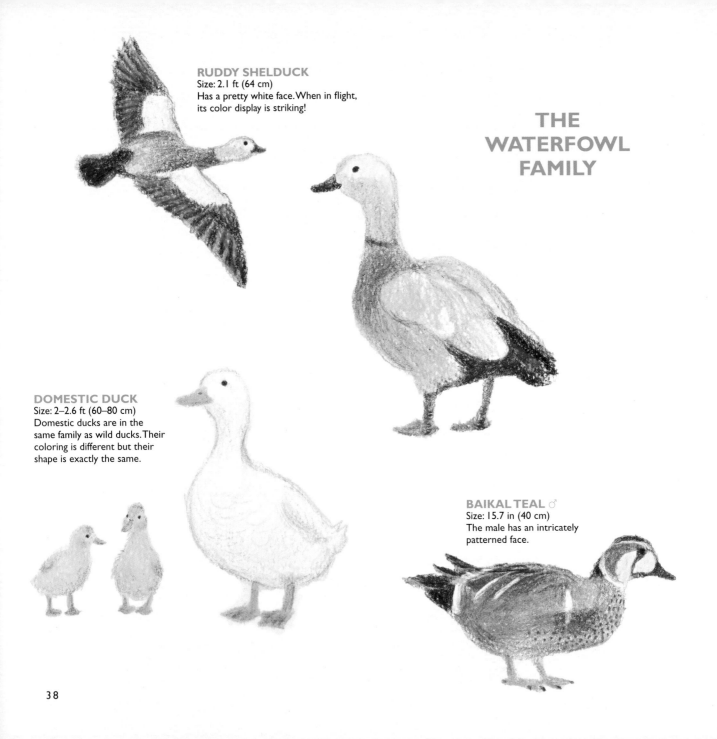

RUDDY SHELDUCK
Size: 2.1 ft (64 cm)
Has a pretty white face. When in flight,
its color display is striking!

THE
WATERFOWL
FAMILY

DOMESTIC DUCK
Size: 2–2.6 ft (60–80 cm)
Domestic ducks are in the
same family as wild ducks. Their
coloring is different but their
shape is exactly the same.

BAIKAL TEAL ♂
Size: 15.7 in (40 cm)
The male has an intricately
patterned face.

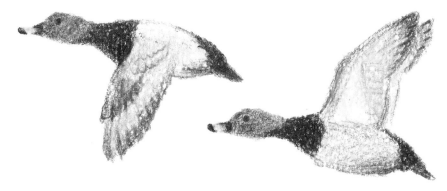

POCHARD ♂
Size: 18.9 in (48 cm)
The male's face is a beautiful reddish brown, while his chest and throat are black, and wings are white.

TUFTED DUCK
Size: 17.3 in (44 cm)
The characteristic tuft at the back of its head is worthy of Greased Lightning and its eyes are golden.

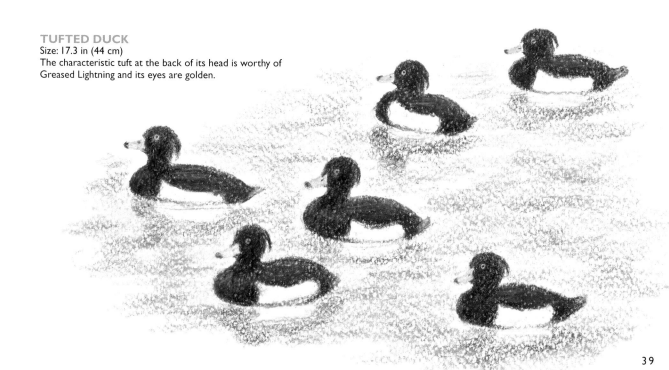

SWAN [Mute swan]

This graceful, pure white bird often appears in fairy tales. You can set off the white of the swan by coloring water around it.

Species order and family:

Anseriformes, Anatidae

Size: 4.7 ft (142 cm)

Found in northern countries like Siberia, they raise their young during summertime, and in winter, when there are no grasses or roots to eat, the entire family heads south to places like Japan.

Has a knoblike protrusion

Neck is longer than a duck's

Swan's body

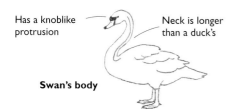

1.

Sketch the outline in sky blue, then draw the bill with your orange pencil. In black, add nostrils, the part above the bill where the knob is, and the eye.

2.

Again, with sky blue, color in the surrounding water, bringing out the shape of the swan. Rather than color it in by tracing the shape, move the colored pencil in one direction to make sure it's even.

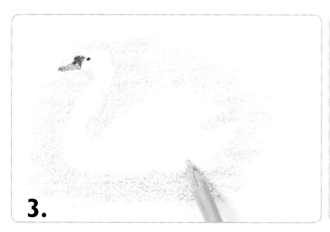

3.

For a 3D effect, lightly fill in the body with bluish gray, and draw a few of the feathers.

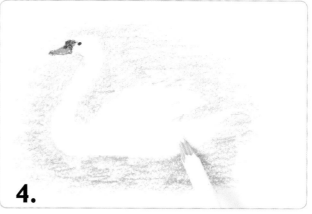

4.

Color in the surface of the water again, pressing firmly with sky blue. Finally, go over the blank parts with white.

41

BLACK SWANS AND GEESE

Wild ducks, swans, and geese…these are all migratory birds that live near water. They are all members of the waterfowl family *Anatidae*.

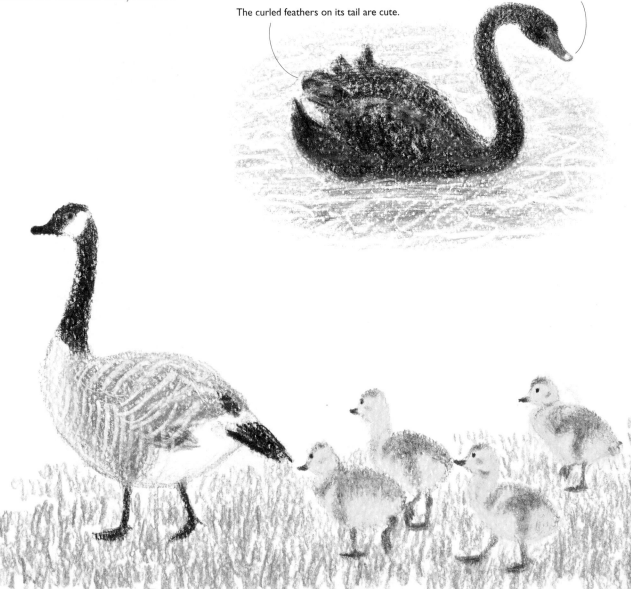

The curled feathers on its tail are cute.

Has a spot of white on the tip of its red bill.

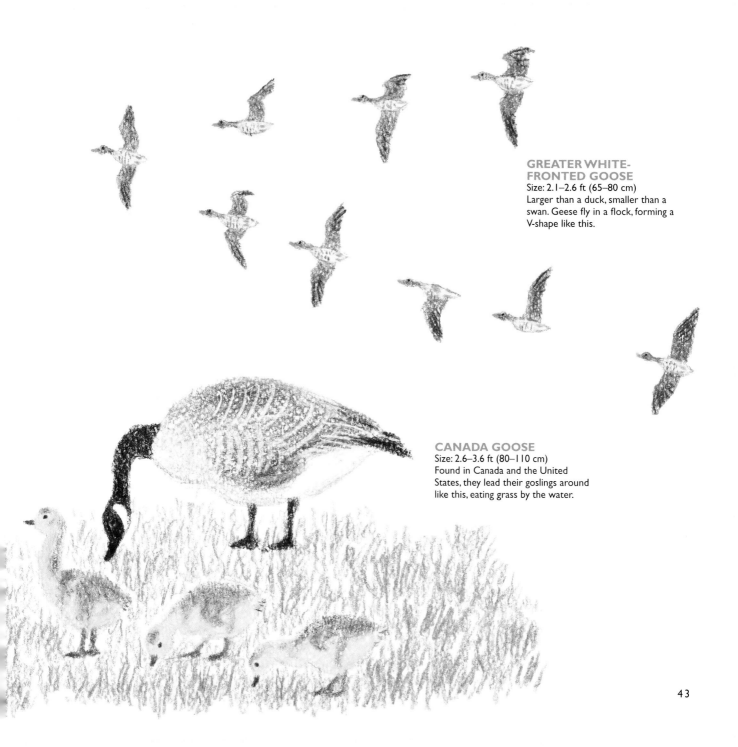

GREATER WHITE-FRONTED GOOSE
Size: 2.1–2.6 ft (65–80 cm)
Larger than a duck, smaller than a swan. Geese fly in a flock, forming a V-shape like this.

CANADA GOOSE
Size: 2.6–3.6 ft (80–110 cm)
Found in Canada and the United States, they lead their goslings around like this, eating grass by the water.

43

part

BIRDS WE MIGHT LIKE TO KNOW MORE ABOUT

Large birds that are found amongst the grandeur of nature, birds
that dwell near the ocean or rivers, birds that live in faraway
places such as Africa. There are so many birds in the world, each
with distinctive characteristics or skills tailored to where they live
or what they eat. The more you learn about birds, the more you
will enjoy drawing them.

OWL

These mysterious birds often appear in fairy tales as knowledgeable experts or magical creatures. They differ from other birds in that both eyes face frontward.

Species order and family:
Strigiformes, Strigidae

Size: 19.7 in (50 cm)

Nocturnal, owls spend most of the day sleeping. When hunting, they set their sights and home in on their prey, which is why their eye placement is the same as other carnivorous animals.

Owl's body

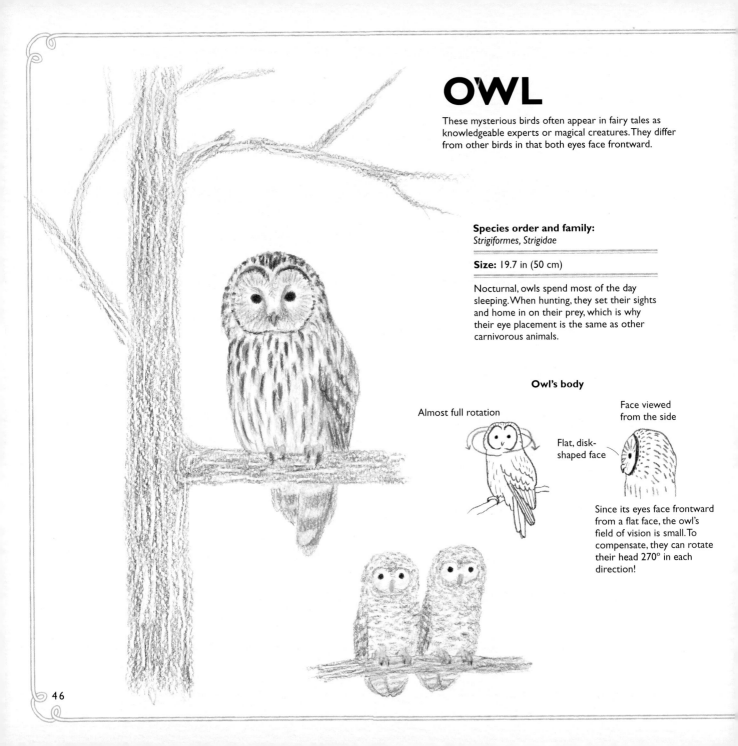

Almost full rotation

Flat, disk-shaped face

Face viewed from the side

Since its eyes face frontward from a flat face, the owl's field of vision is small. To compensate, they can rotate their head 270° in each direction!

1.

Sketch the shape of the entire body in bluish gray.

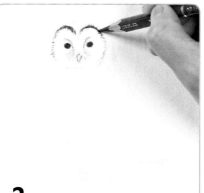

2.

Draw the eyes with black pencil. Sketch the face in the shape of a heart and, using dark brown, clearly add the features of the face.

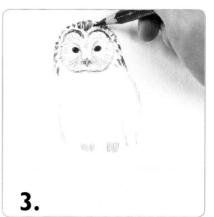

3.

With your deep yellow pencil, draw the beak and feet. For a subtle 3D effect, draw the rest of the facial elements in dark brown. Then draw the feathers on the head and outline the rest of the body.

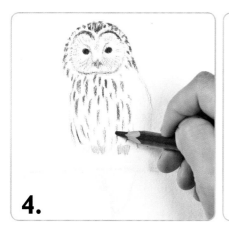

4.

Add feathers on the body with dark brown pencil. Pay attention that the fluffy feathers follow the shape of the body.

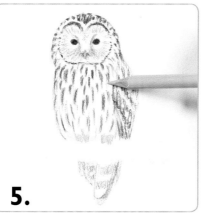

5.

Keep your dark brown pencil to draw a striped pattern on the tail. Then, with bluish gray, light bluish gray, brown, and light purple, lightly trace the tufts of feathers. This brings out the softness.

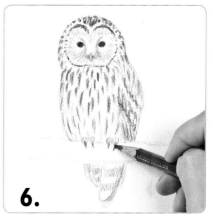

6.

Finally, add talons using black.

THE OWL FAMILY

There are many species of owls, and they differ greatly in size.

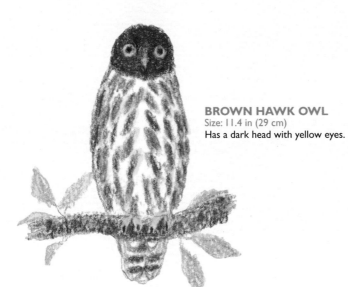

BROWN HAWK OWL
Size: 11.4 in (29 cm)
Has a dark head with yellow eyes.

Horned owls have ornamental feathers called "ear tufts."
*These are not their actual ears.

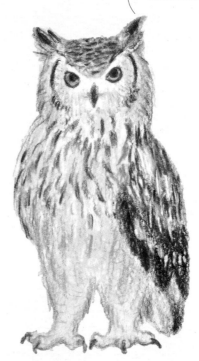

BARN OWL
Size: 13.4 in (34 cm)
Face is heart-shaped.

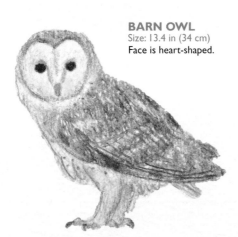

EURASIAN EAGLE-OWL
Size: 19.7–22 in (50–56 cm)
Large, robust body.

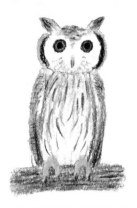

AFRICAN SCOPS OWL
Size: 7.5–9.4 in (19–24 cm)
This owl is very timid, and when on alert, its body becomes incredibly slender.

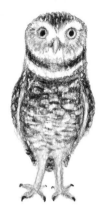

BURROWING OWL
Size: 7–10.2 in (18–26 cm)
Lives in grasslands, and instead of burrowing on its own, uses burrows formerly excavated by prairie dogs and other animals.

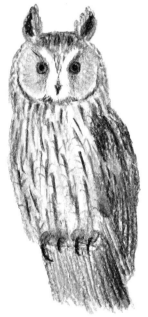

LONG-EARED OWL
Size: 15 in (38 cm)
Vertical striped pattern on the body.

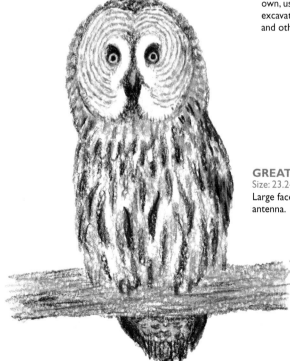

GREAT GREY OWL
Size: 23.2–27.2 in (59–69 cm)
Large face that looks like a parabolic antenna.

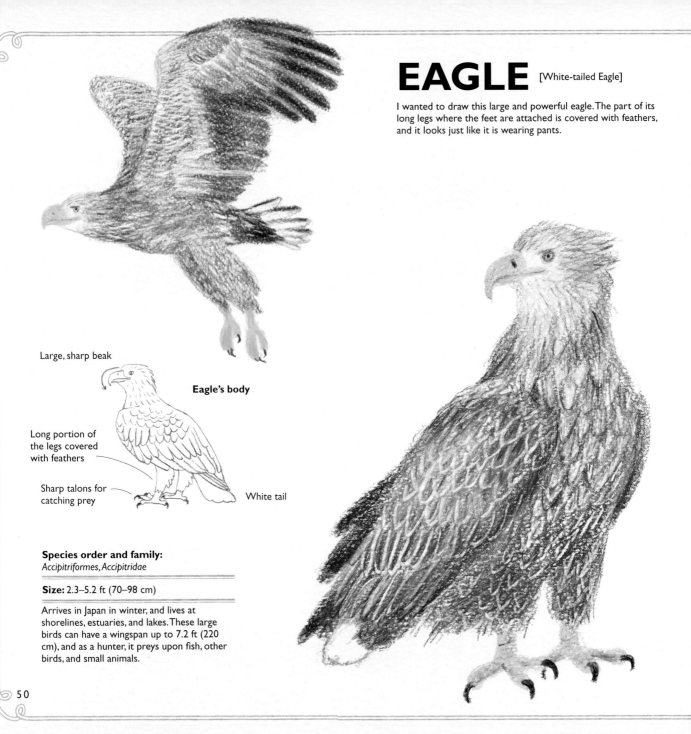

EAGLE [White-tailed Eagle]

I wanted to draw this large and powerful eagle. The part of its long legs where the feet are attached is covered with feathers, and it looks just like it is wearing pants.

Large, sharp beak

Eagle's body

Long portion of the legs covered with feathers

Sharp talons for catching prey

White tail

Species order and family:
Accipitriformes, Accipitridae

Size: 2.3–5.2 ft (70–98 cm)

Arrives in Japan in winter, and lives at shorelines, estuaries, and lakes. These large birds can have a wingspan up to 7.2 ft (220 cm), and as a hunter, it preys upon fish, other birds, and small animals.

 Colored pencils used for eagle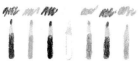

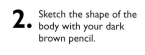

1. Begin to draw the shape of the face with dark brown pencil, keeping balance in mind as you draw the beak in orangish yellow. Also with orangish yellow, add the area around the eye, and then draw the eye and the nostrils in black.

2. Sketch the shape of the body with your dark brown pencil.

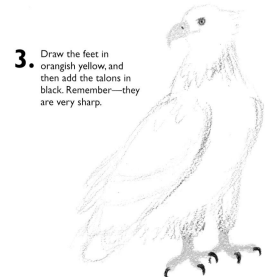

3. Draw the feet in orangish yellow, and then add the talons in black. Remember—they are very sharp.

4. Using dark brown, begin to draw the feathers. They differ in shape, size, and movement depending on the part of the body where they appear.

 51

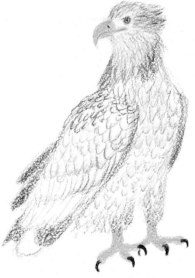

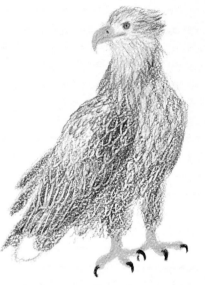

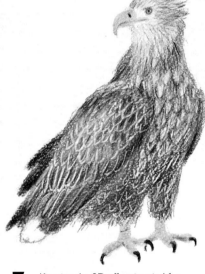

5. Color in the face and the chest with off-white. Once you've drawn along the edges of the chest's scale-shaped feathers, color in each of them. From the wing to the belly to the feathers on the lower parts, only draw along the edge. Later when you color in with a darker shade, the white will pop, as you can see in the next images. (Don't they look like photos?)

6. With your dark brown pencil, color in the entire body and then add a layer of tan. Give a 3D effect to its impressive wing by using dark brown.

7. Keeping the 3D effect in mind for the entire body, layer the colors with midnight gray, tan, and light gray. Add lots of color to the darker areas, such as the base of the throat, the underside of the wing, and the leg joints. Color in any spots on the body with off-white, and you're finished.

NORTHERN GOSHAWK
Size: 19.7 in (50 cm)
Distinctive white striping above
and a black pattern around the eye.

**CRESTED
SERPENT EAGLE**
Size: 21.7 in (55 cm)
Found in the Yaeyama
Islands of Okinawa, Japan,
its head looks like it is
topped with a black and
white speckled crown.

THE EAGLE AND HAWK FAMILY

In the birds of prey family *Accipitridae*, for the most part, larger birds are eagles while
medium-sized birds are more often called hawks.

BALD EAGLE
Size: 2.5–3 ft (76–92 cm)
Large North American
eagle with white from its
head to its throat.

LITTLE GREBE

This water bird has a beautiful reddish brown head and is smaller than a wild duck. In early summer, you can see them leading around their adorable striped chicks.

Little grebe's body

Swimming

Standing

The end of its bill is pale yellow.

Deep red color

Puffy feathers

Interesting foot shape (see p. 9)

(see p. 9)

Species order and family:
Podicipediformes, Podicipedidae

Size: 10.2 in (26 cm)

Lives in ponds, marshes, and lakes, and doesn't come up onto land very often. Sometimes it carries its young on its back.

Its feet are for paddling water rather than for walking, so they are attached near the rump. Their stance is like this, much different than a duck's.

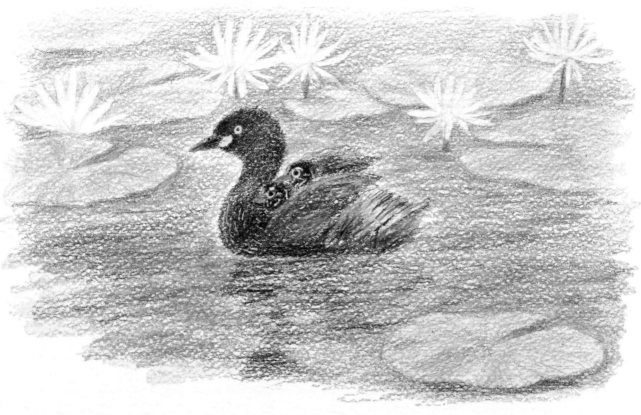

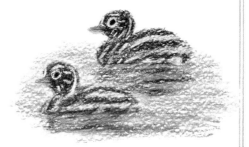

With their stripes, the cute little chicks look like wild boar piglets with red bills.

1. Draw the bill using black pencil. Leaving spots for the pattern around the eye, draw the head with dark purple. Lightly color in the blank parts with yellow.

2. Draw the mauve pattern from the cheek to the throat, layering over it with reddish orange. Using black, draw the pupil.

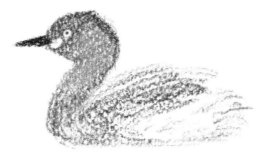

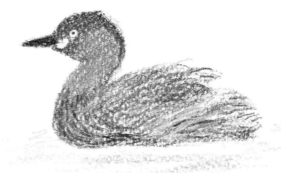

3. Sketch the body with dark purple, including a clear color shift on the throat. Draw tightly packed feathers to give a soft, fluffy appearance.

4. Add more tightly packed feathers on the wing using your tan pencil, and then layer over the entire body with reddish orange and dark brown. Using moss green, color in lightly to suggest the surface of the water.

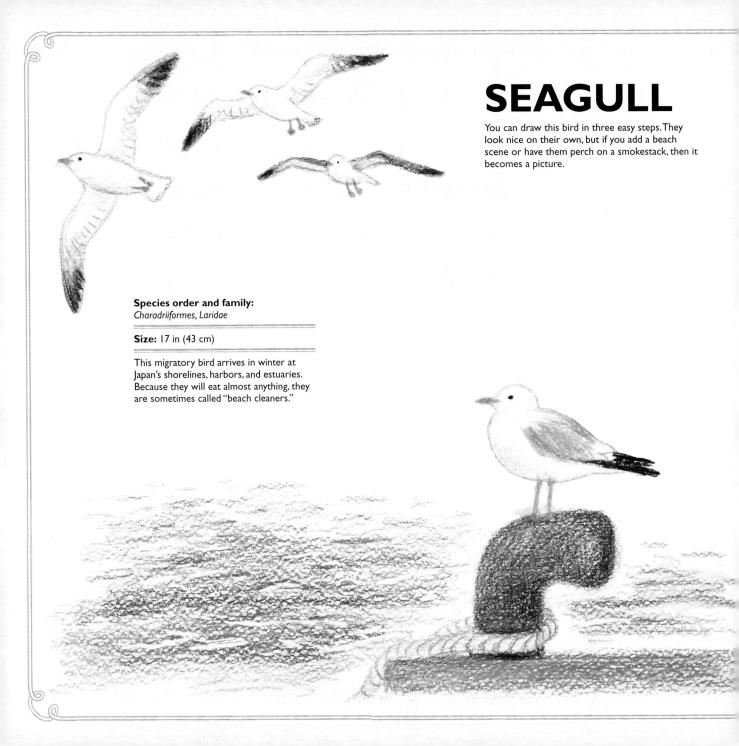

SEAGULL

You can draw this bird in three easy steps. They look nice on their own, but if you add a beach scene or have them perch on a smokestack, then it becomes a picture.

Species order and family:
Charadriiformes, Laridae

Size: 17 in (43 cm)

This migratory bird arrives in winter at Japan's shorelines, harbors, and estuaries. Because they will eat almost anything, they are sometimes called "beach cleaners."

Standing

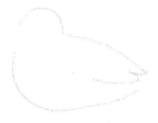

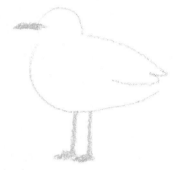

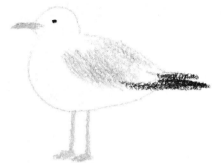

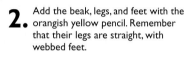

1. Outline the body with your gray pencil.

2. Add the beak, legs, and feet with the orangish yellow pencil. Remember that their legs are straight, with webbed feet.

3. Color in the wing with bluish gray and gray and then switch to black to draw the eye, the tip of the wing, and the tail.

Flying

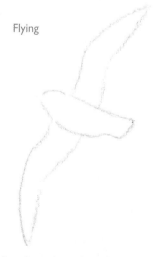

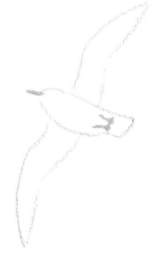

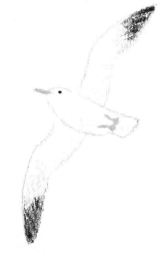

1. Draw the outline of the body in gray.

2. With the orangish yellow pencil, draw the beak and feet.

3. Add definition to the wings with the bluish gray pencil, and then, with black, draw the eye and color in the dark tips of the wings.

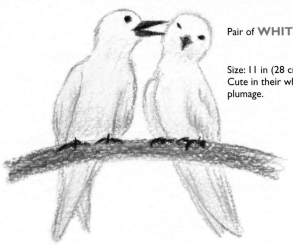

Pair of **WHITE TERNS**

Size: 11 in (28 cm)
Cute in their white plumage.

White tern chick

LITTLE TERN
Size: 9.4 in (24 cm)
Terns seem very long from their rump to the tip of their tail, and they have skinny little legs.

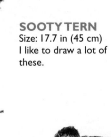

THE TERN FAMILY

Terns flock to shorelines in large groups, and they are members of the *Sternidae* family, part of the order *Charadriiformes*.

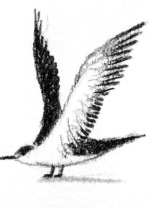

SOOTY TERN
Size: 17.7 in (45 cm)
I like to draw a lot of these.

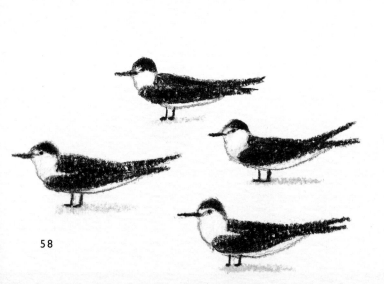

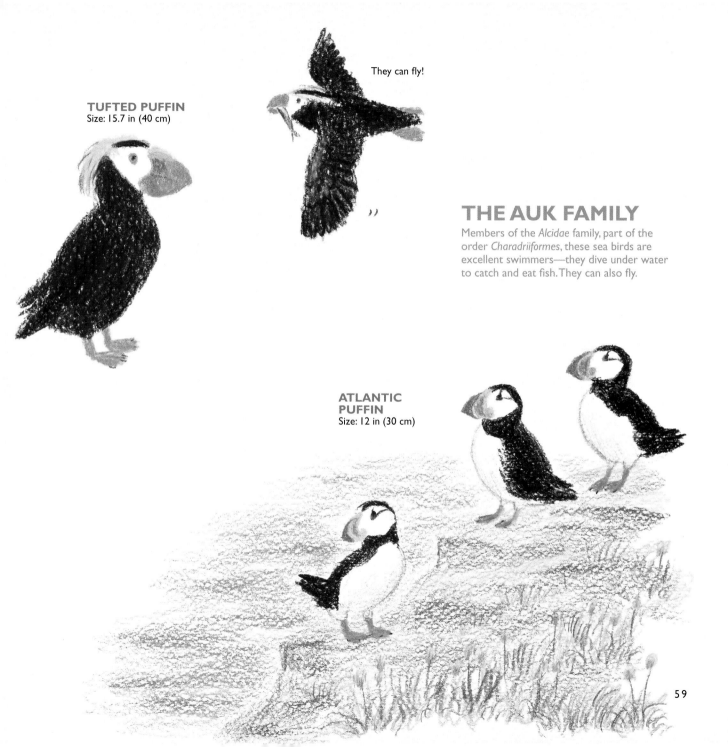

TUFTED PUFFIN
Size: 15.7 in (40 cm)

They can fly!

THE AUK FAMILY

Members of the *Alcidae* family, part of the order *Charadriiformes*, these sea birds are excellent swimmers—they dive under water to catch and eat fish. They can also fly.

ATLANTIC PUFFIN
Size: 12 in (30 cm)

LANDSCAPE AT THE BEACH

Plovers and Sandpipers

On winter beaches, you can see groups of plovers and sandpipers. Look closely and notice the length of their bills and the shape of their bodies.

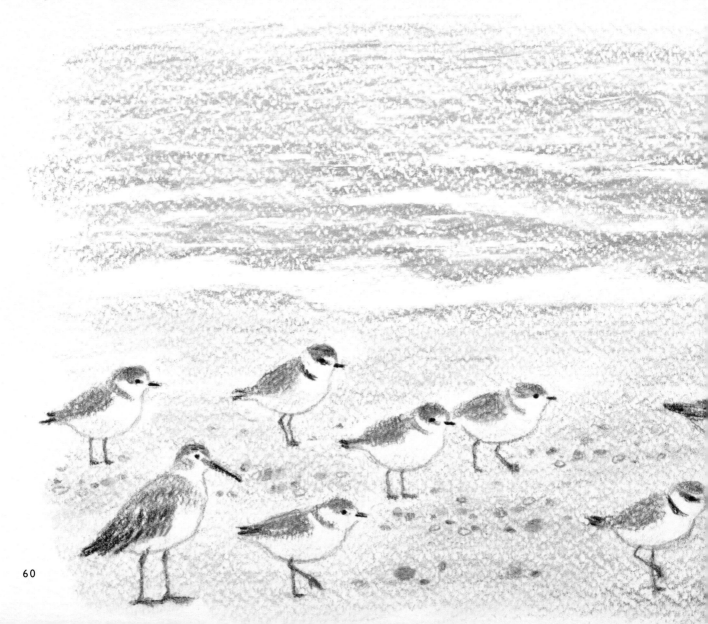

Plovers in flight

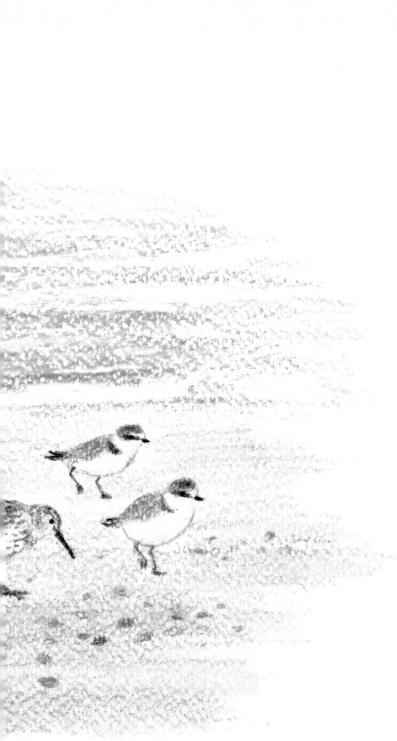

SNOWY PLOVER
Species order and family:
Charadriiformes, Charadriidae
Size: 6 in (15 cm)
The slightly smaller ones with brown heads and short bills are snowy plovers. They live in groups on sandy beaches, tidal flats, and wetlands.

DUNLIN
Species order and family:
Charadriiformes, Scolopacidae
Size: 8.3 in (21 cm)
The slightly bigger ones with longer bills are dunlins. On sandy beaches, they peck at the ground to find crustaceans and insects to eat.

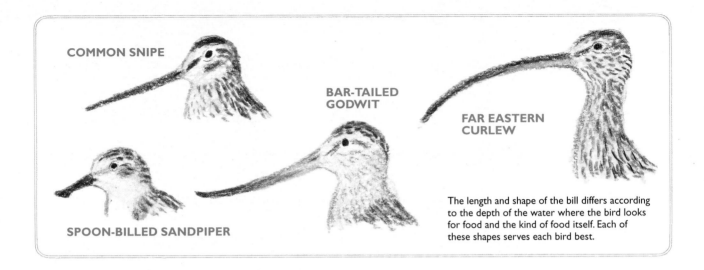

COMMON SNIPE

SPOON-BILLED SANDPIPER

BAR-TAILED GODWIT

FAR EASTERN CURLEW

The length and shape of the bill differs according to the depth of the water where the bird looks for food and the kind of food itself. Each of these shapes serves each bird best.

GREATER PAINTED SNIPE ♂ WITH CHICKS

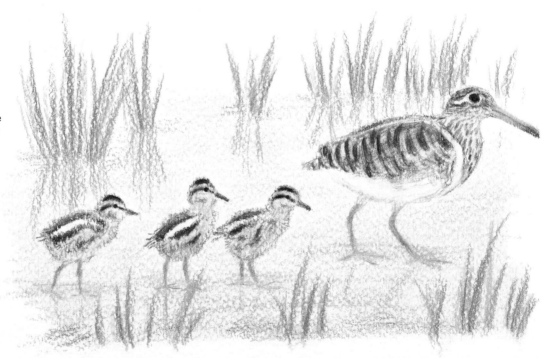

Size: 9–11 in (23–28 cm)
The greater painted snipe is unusual among birds in that the female is more brightly colored than the male. It is also the male who incubates the eggs and raises the young.

THE SANDPIPER FAMILY

They vary in color but they all have long, narrow bills for digging in the mud of a marsh or the sand at the beach as they look for food such as crustaceans and insects.

BLACK-NECKED STILT
Size: 14.2 in (36 cm)
True to its name, this bird has black markings on the back of its neck. Its legs are really long compared to the size of its body.

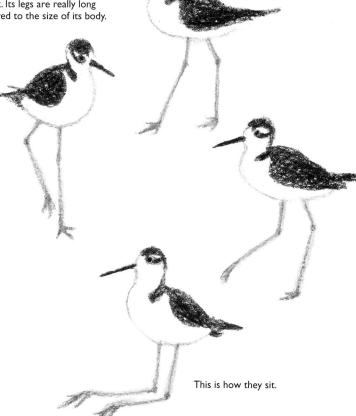

This is how they sit.

GREATER PAINTED SNIPE ♀

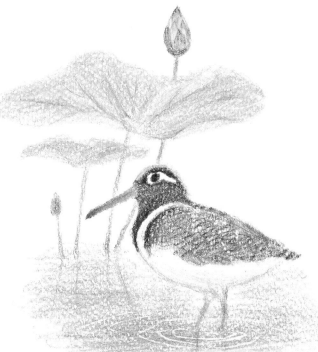

GREY HERON

When looking off in the distance, this bird stands fully erect, but when it's cold or resting, the heron ducks its head in close. It can be challenging to draw the long neck, so let's break the steps down little by little.

Long and narrow bill

Ornamental feathers (crest)

Grey heron's body

The feathers that grow here are long, narrow, and scruffy.

Species order and family:
Pelicaniformes, Ardeidae

Size: 2.9–3.2 ft (88–98 cm)

Grey herons are monogamous, the same couples returning to the same nest every spring to lay eggs. They often breed in colonies, with many pairs of herons gathered together to form a group to raise their young.

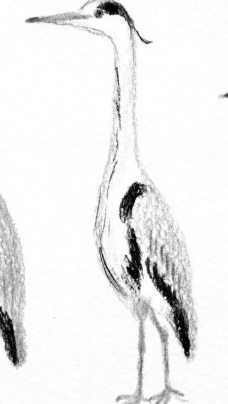

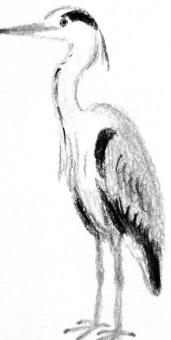

Colored pencils used for grey heron

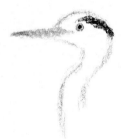

1. Sketch the shape of the head using bluish gray. The part where the head becomes the neck is challenging, so look closely and go slowly.

2. Begin drawing the bill in deep yellow, and then decide on the position of the eye.

3. With your black pencil, draw the pattern on the head that looks like an eyebrow.

4. The curve and length of the neck are important, so decide the shape based on the bird's height and then draw it with bluish gray.

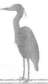

Grey Heron

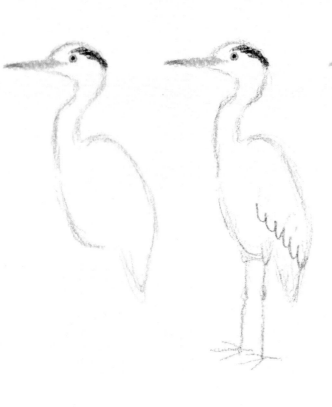
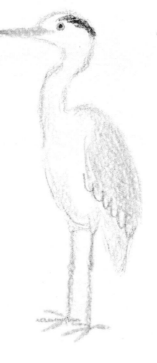
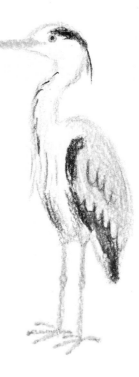

5. Still using your bluish gray pencil, sketch the shape of the back, wing, belly, and tail. Pay close attention to the form.

6. Draw the legs and feet. There is a small area covered in feathers where the legs attach. They have three toes in front and one in the back.

7. Layer the legs with deep yellow and color in the wing with bluish gray. Next, lightly shade the neck, the lower part of the belly, and the tail.

8. Draw the ornamental feathers behind the head, the pattern on the throat, and the dark patches on the wing using your black pencil. Then add the long, scruffy chest feathers.

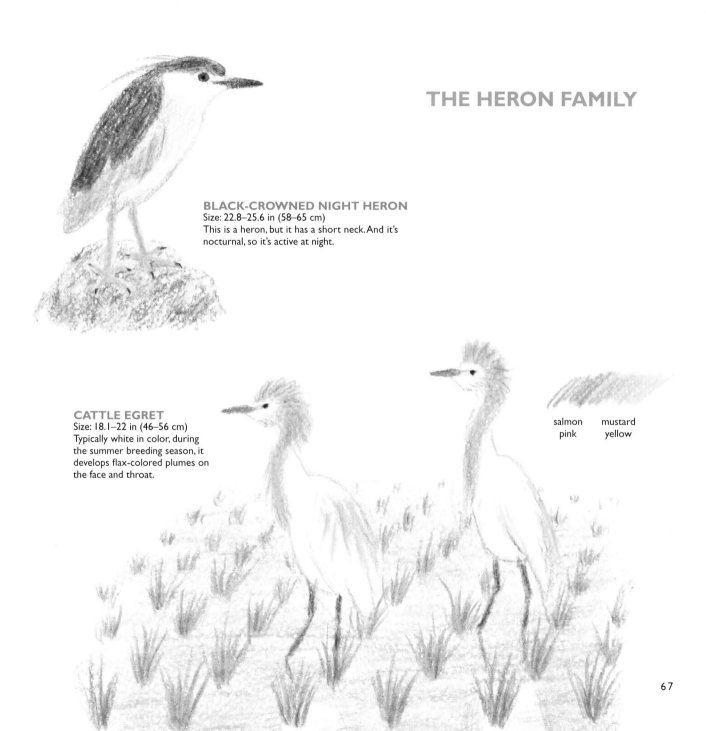

THE HERON FAMILY

BLACK-CROWNED NIGHT HERON
Size: 22.8–25.6 in (58–65 cm)
This is a heron, but it has a short neck. And it's
nocturnal, so it's active at night.

CATTLE EGRET
Size: 18.1–22 in (46–56 cm)
Typically white in color, during
the summer breeding season, it
develops flax-colored plumes on
the face and throat.

salmon mustard
pink yellow

PELICAN [Great white pelican]

The pouch in its bill is used for catching fish, and the rest of the body is plump and round with pinkish legs. Watch the pelican for its humorous behavior!

Pelican's body

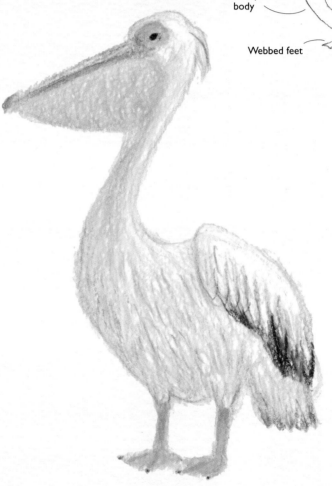

- Large bill
- Throat pouch
- Plump, round body
- Webbed feet

Species order and family:
Pelicaniformes, Pelicanidae

Size: 4.6–5.6 ft (140–170 cm)
(Its bill is about 17.7 in [45 cm])

Lives in the vicinity of lakes, marshes, and estuaries. Has a throat pouch in the bottom of its bill. Feeds cooperatively with other pelicans to trap and catch fish.

This is what one looks like from the front.

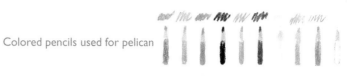

1.

Roughly draw the shape with your tan pencil. It's easiest to get the shape right if you draw in this order: bill, head, neck, back, wing, tail, belly, thighs, legs, and feet.

2.

Color in the bill with deep yellow, and then switch to light mauve to fill in the eye area and the top part of the bill.

3.

Draw the eye with black, and then with medium blue, add a line on the top part and in the middle of the bill.

4.

Color in the top portion of the bill again using deep red, giving it a defined shape.

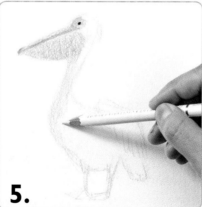

5.

Layer the colors of the lower part of the bill with light mauve and yellow, and then use the same colors to give the neck and chest a faint yellow hue.

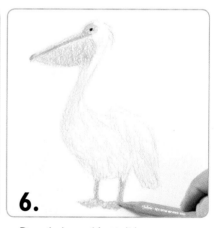

6.

Draw the legs and feet in light mauve, turning the toes slightly inward.

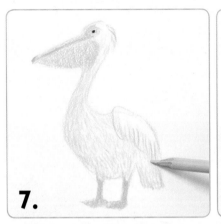

7.

Pressing lightly with light pink, draw tufts of feathers and outline the wing. Layer over the legs and feet with the same color.

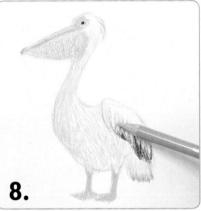

8.

Using black, draw the tips of the wing and tail. Then lightly add a coat of feathers over the entire body with your bluish gray pencil.

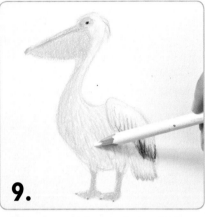

9.

Fill in the areas left on the body with white.

It's fun to draw them with different expressions.

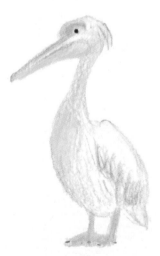

With its throat pouch contracted…

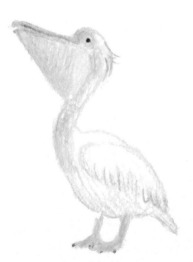

With it expanded…

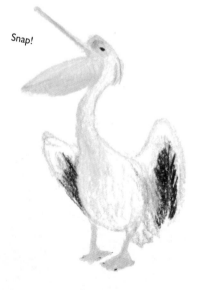

Snap!

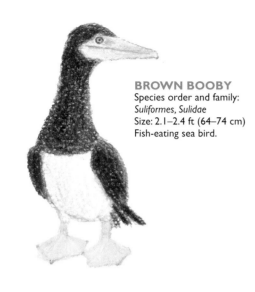

BROWN BOOBY
Species order and family:
Suliformes, Sulidae
Size: 2.1–2.4 ft (64–74 cm)
Fish-eating sea bird.

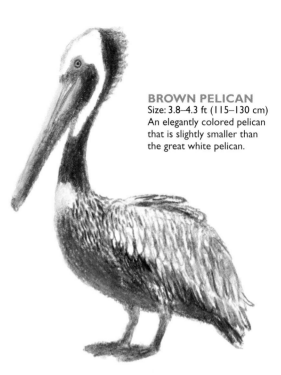

BROWN PELICAN
Size: 3.8–4.3 ft (115–130 cm)
An elegantly colored pelican
that is slightly smaller than
the great white pelican.

THE PELICAN AND BOOBY FAMILIES

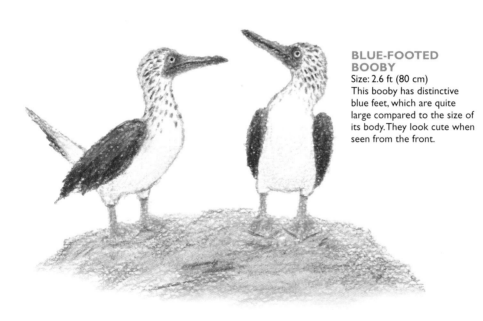

BLUE-FOOTED BOOBY
Size: 2.6 ft (80 cm)
This booby has distinctive
blue feet, which are quite
large compared to the size of
its body. They look cute when
seen from the front.

The males strut around
the females during their
mating ritual, lifting up
their feet and dancing!

SHOEBILL

A favorite at the zoo, the shoebill is a large bird with a unique expression. From the feathers on its head that stand up straight to its large bill, it has plenty of charming features.

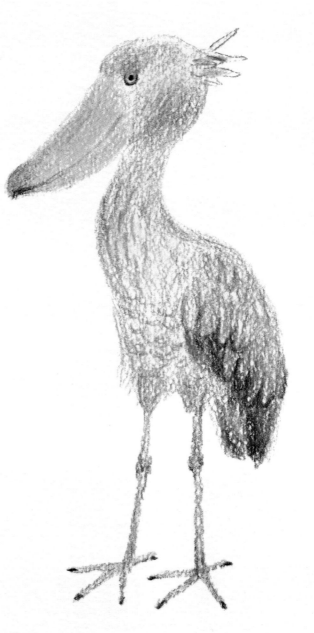

Species order and family:
Pelicaniformes, Balaenicipitidae

Size: 3.6–4.6 ft (110–140 cm)
(Its bill is about 8.7 in [22 cm])

Wild shoebills live in African wetlands. Solitary in nature, you'll often find one on its own. When agitated or startled, it can fly long distances. Its name comes from the shape of its bill, which resembles a wooden shoe.

Shoebill's body

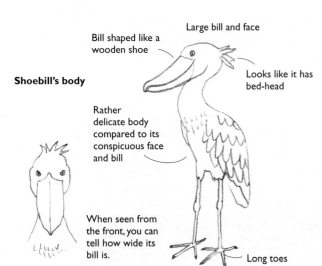

Bill shaped like a wooden shoe

Large bill and face

Looks like it has bed-head

Rather delicate body compared to its conspicuous face and bill

When seen from the front, you can tell how wide its bill is.

Long toes

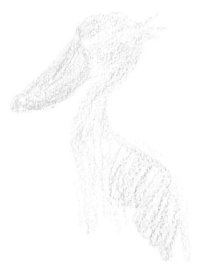

1. With your light pink pencil, draw the bill in the shape of a wooden shoe.

2. Using bluish gray, draw the face.

3. Begin drawing the body in bluish gray. Pay attention when sketching the shape of the neck and back—the torso is short.

They stand very still for long periods, and when fish come near, they catch and eat them. Occasionally they miss.

Wild shoebills eat lungfish.

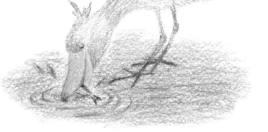

73

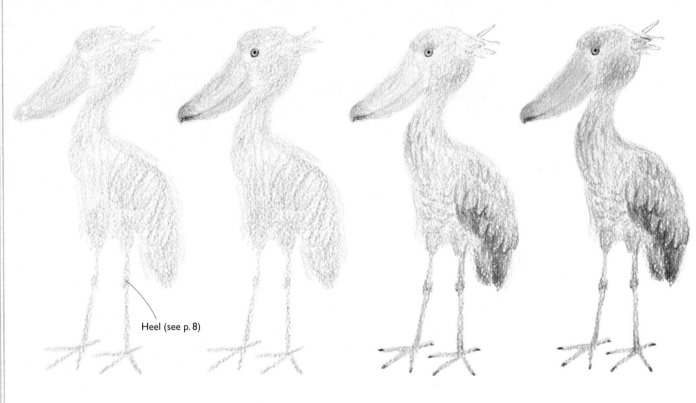

Heel (see p. 8)

4. Draw the tail, legs, and feet. Make sure to draw the heel on the foot. Its toes are quite long.

5. Add the eye with your black pencil and, pressing lightly, darken near the tip of the bill. Draw the line on the bill with bluish gray. In profile, it looks like it is smiling.

6. Begin to draw the feathers using black. Layer colors on the face, add long scruffy feathers on the chest, and draw the round, scale-like feathers on the belly one at a time. Press down firmly for the lower part of the wing. Make the shape of the heel obvious, and then draw the claws.

7. Being careful to maintain balance over the entire body, use black to firmly go over the dark areas. Layer with periwinkle, and then with mustard yellow, layer the color on the bill.

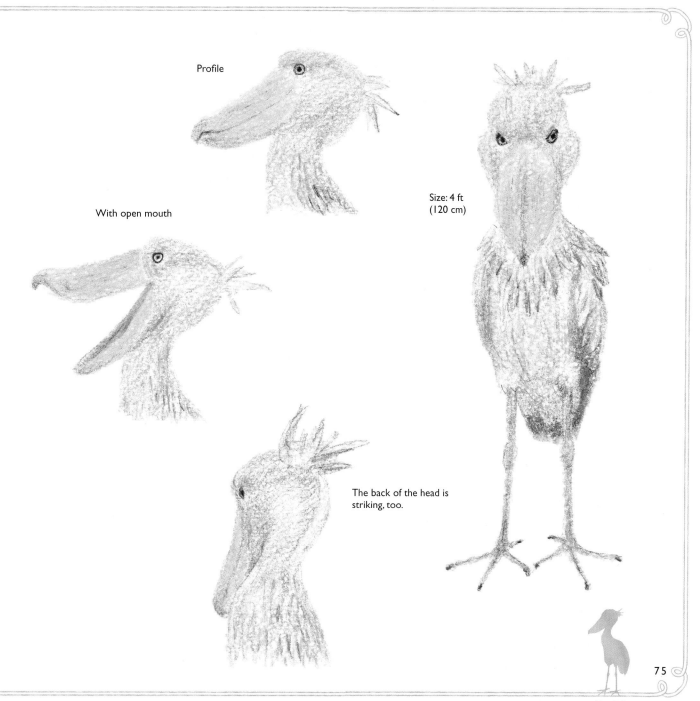

Profile

With open mouth

Size: 4 ft
(120 cm)

The back of the head is
striking, too.

75

Shoebill

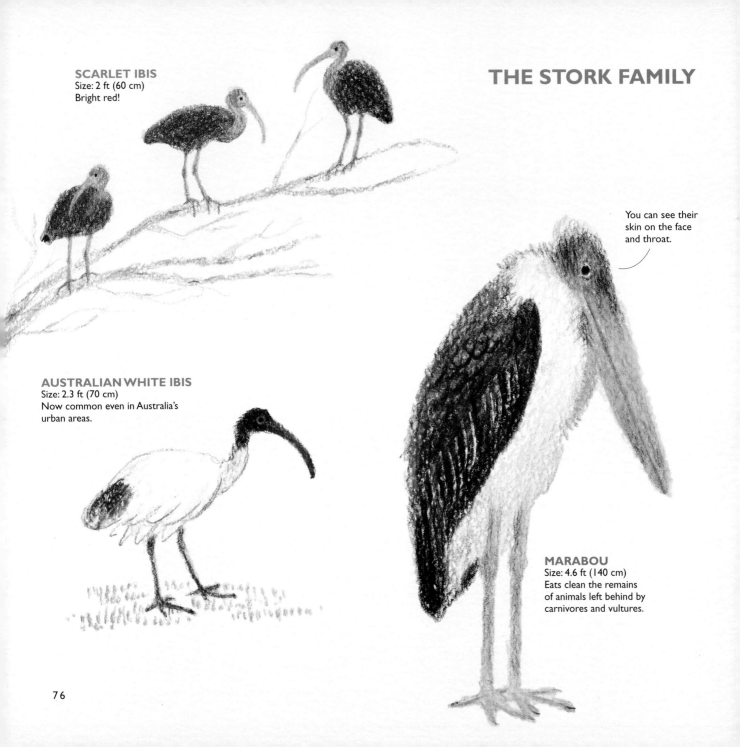

SCARLET IBIS
Size: 2 ft (60 cm)
Bright red!

THE STORK FAMILY

You can see their skin on the face and throat.

AUSTRALIAN WHITE IBIS
Size: 2.3 ft (70 cm)
Now common even in Australia's urban areas.

MARABOU
Size: 4.6 ft (140 cm)
Eats clean the remains of animals left behind by carnivores and vultures.

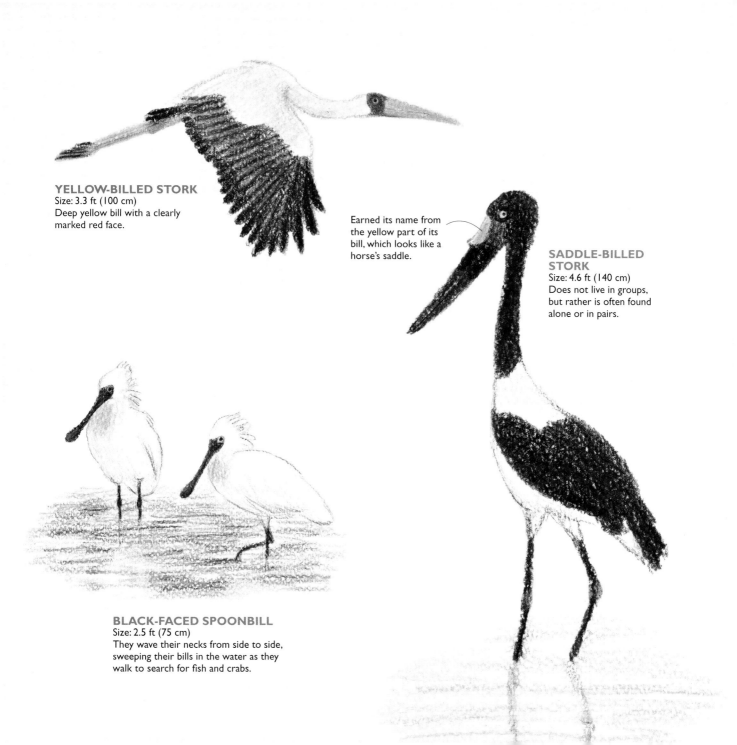

YELLOW-BILLED STORK
Size: 3.3 ft (100 cm)
Deep yellow bill with a clearly
marked red face.

Earned its name from
the yellow part of its
bill, which looks like a
horse's saddle.

**SADDLE-BILLED
STORK**
Size: 4.6 ft (140 cm)
Does not live in groups,
but rather is often found
alone or in pairs.

BLACK-FACED SPOONBILL
Size: 2.5 ft (75 cm)
They wave their necks from side to side,
sweeping their bills in the water as they
walk to search for fish and crabs.

FLAMINGO

This beautiful bird lives in large colonies. They bend their legs and their necks to assume various poses. Their feathers change color as they mature.

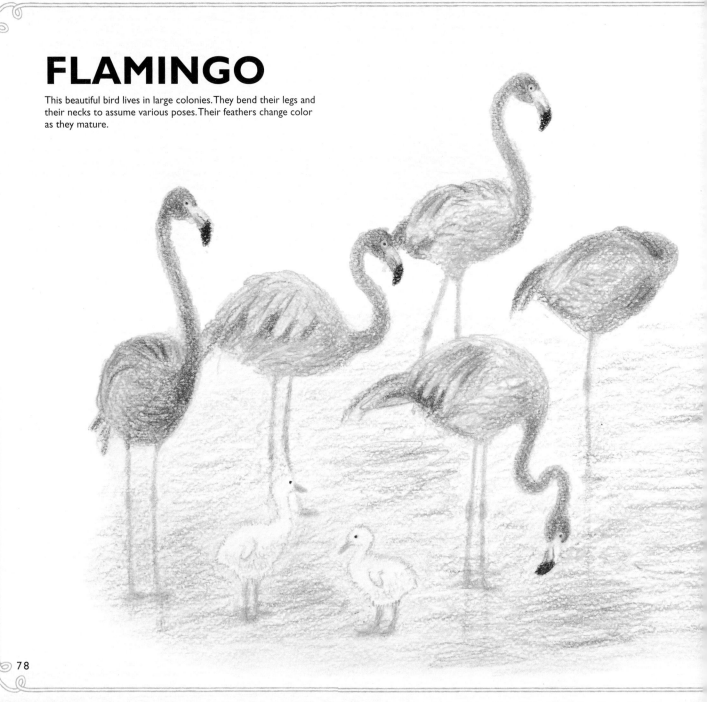

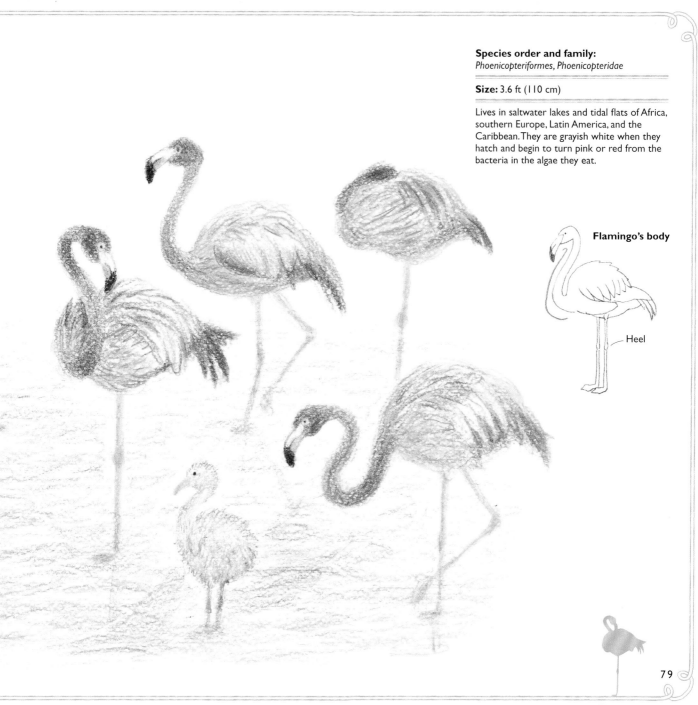

Species order and family:
Phoenicopteriformes, Phoenicopteridae

Size: 3.6 ft (110 cm)

Lives in saltwater lakes and tidal flats of Africa, southern Europe, Latin America, and the Caribbean. They are grayish white when they hatch and begin to turn pink or red from the bacteria in the algae they eat.

Flamingo's body

Heel

79

1. With your light mauve pencil, sketch the shape of the face. The bill is curved like a bow.

2. Next, draw the light mauve neck. Here, I drew it in the shape of an "S." Using black, darken the tip of the bill and draw the eye.

3. Lightly color in the middle area of the bill with light mauve. Switching to deep red, layer over the face and neck, and then draw the back.

Colored pencils used for flamingo

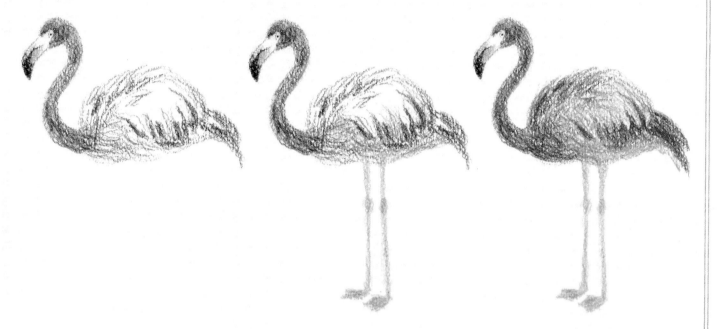

4. Sketch and color in the body using deep red. Adjust the direction you move the colored pencil according to the various ways the feathers grow. Pressing lightly, color in the belly with mauve.

5. Draw the legs and feet with your pink pencil.

6. Layer the color around the tip of the wing and on the legs and feet with purple. Then layer the back with orange. Continue to layer color over the entire body with light mauve and buff.

OSTRICH

Instead of flying, the ostrich can run amazingly fast. With its large body and powerful legs, it differs quite a lot from other birds and is flightless.

♂

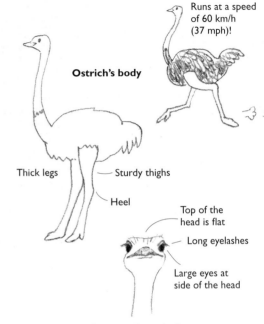

Ostrich's body

Runs at a speed of 60 km/h (37 mph)!

Thick legs — Sturdy thighs

— Heel

Top of the head is flat

— Long eyelashes

Large eyes at side of the head

Face seen from the front

Species order and family:
Struthioniformes, Struthionidae

Size: 7.5 ft (230 cm)

Lives in groups on the savannas and in the deserts of Africa. Eats grasses, seeds, and fruit. Females, who lay large eggs in the summer, are grayish brown in color.

Two-toed ostrich foot

Colored pencils used for ostrich

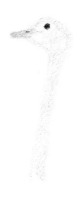

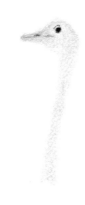

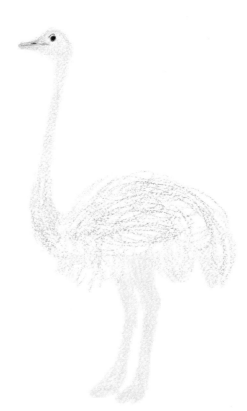

1. Roughly draw the shape of the face and neck using bluish gray. Next, add the beak with pink and then the eye and nostrils with black.

2. Using buff, color in the whole head and neck, and then lightly layer over it with bluish gray. Add the line on the beak and the double fold above the eye with bright red.

3. Draw the body with your bluish gray pencil. Next, fill in the rustled feathers on the torso, following various directions. Using buff, draw the legs and feet.

83

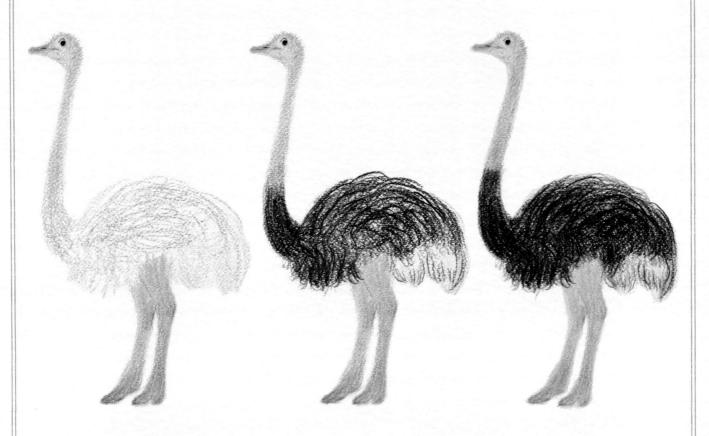

4. Create bristly feathers on the face using bluish gray. Layer over the legs and feet with pink, and clearly define their shape using midnight gray.

5. Roughly color in the body with your black pencil.

6. Press firmly to roughly layer over the body with midnight gray, dark brown, and tan. Add one last layer of black and then color in the tail with buff.

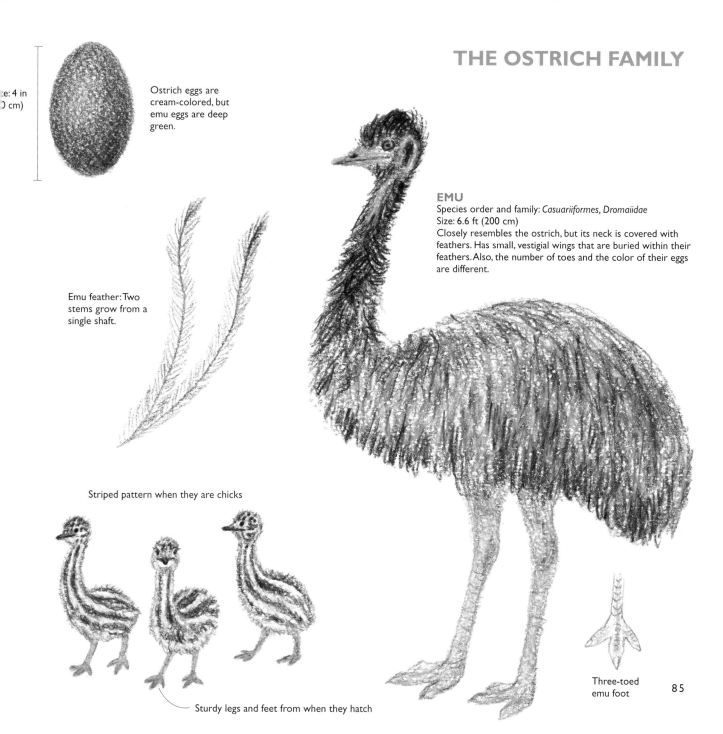

Size: 4 in
(10 cm)

Ostrich eggs are cream-colored, but emu eggs are deep green.

EMU
Species order and family: *Casuariiformes, Dromaiidae*
Size: 6.6 ft (200 cm)
Closely resembles the ostrich, but its neck is covered with feathers. Has small, vestigial wings that are buried within their feathers. Also, the number of toes and the color of their eggs are different.

Emu feather: Two stems grow from a single shaft.

Striped pattern when they are chicks

Sturdy legs and feet from when they hatch

Three-toed emu foot

85

EMPEROR PENGUIN

The emperor penguin is the largest of the penguins. The chicks are fluffy and the pattern on their face is adorable.

Species order and family:
Sphenisciformes, Spheniscidae

Size: 3.3–4.3 ft (100–130 cm)

Eats fish, squid, and krill that it catches in the ocean. The most accomplished swimmers in the bird world, they can remain underwater for almost 20 minutes.

1. Sketch the shape of the entire body in bluish gray.

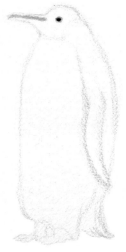

2. Draw a light mauve stripe on the bill. Add the eye with black, but so that it won't be hidden, color around it with bluish gray.

Penguin's body (adult)

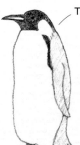

This is the neck

Penguin's body (juvenile)

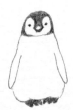

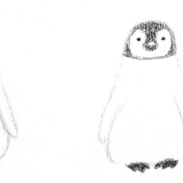

1. Sketch the shape of the entire body using your periwinkle pencil.

2. Using black, draw the pattern on the face, the eyes, and the feet.

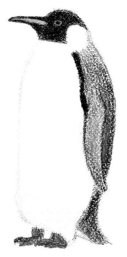

3. Now color in the face with black, leaving the area around the eye empty. Fill in the backside using black, too. Layer the color on the wing and the tip of the tail with bluish gray and light gray.

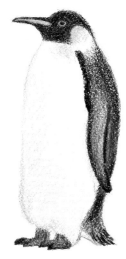

4. Pressing lightly with bluish gray, color in the belly. Layer the dark areas with dark purple, black, and bluish gray. Color in the upper part of the neck with deep yellow, shading it towards the lower area.

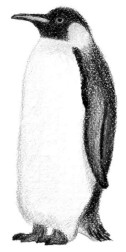

5. Layer the color on the neck with bright yellow. Pressing lightly, color in the belly with sky blue and tan.

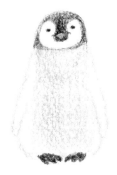

3. Draw the bill in periwinkle, and then softly fill in the belly.

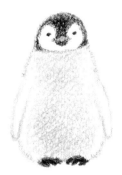

4. Layer over the dark areas with dark purple, and then continue to layer the body with dark purple, mustard yellow, and light bluish gray. Color in the blank parts with white.

Colored pencils used for adult

Colored pencils used for juvenile

87

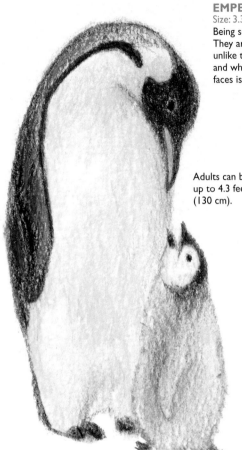

EMPEROR PENGUIN
Size: 3.3 ft (100 cm)
Being so large, they are indeed emperors!
They are white down to their ankles,
unlike the king penguin. Chicks are fluffy
and whitish, and the pattern on their
faces is just adorable.

Adults can be
up to 4.3 feet
(130 cm).

The father also
helps raise the
young.

The chick balances
on its parent's feet to
keep warm.

Emperor penguin chicks huddling to keep warm

EMPEROR PENGUINS AND KING PENGUINS

The emperor penguin is the largest among the penguin species. The king penguin is the second largest. Though the adults look similar, the chicks look quite different.

KING PENGUIN
Size: 2.8–3.1 ft (85–95 cm)
Resembles the emperor penguin but is comparatively smaller and slimmer.

King penguin chicks are brown and fuzzy. Before they lose their fuzz, they are actually larger than their parents.

Differences in the patterns of emperor and king penguins

Open Closed

Emperor penguin King penguin

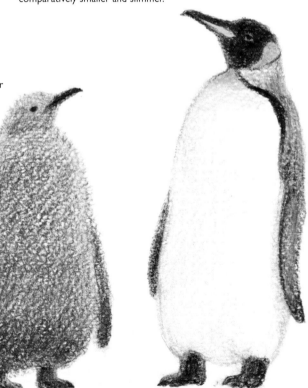

SMALL AND MEDIUM-SIZED PENGUINS

There are many other species of penguins aside from emperor and king penguins. Look closely to see how each of their patterns varies.

LITTLE PENGUIN
Size: 15.7 in (40 cm)
Adults are smaller than emperor penguin chicks. They are slightly blue in color with pink feet.

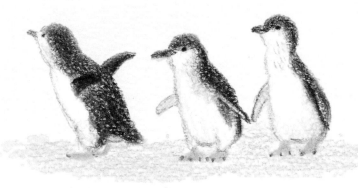

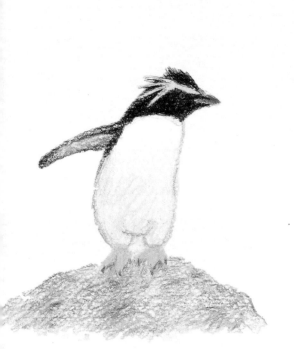

They look alike, but on the Magellanic penguin, the black collar at the throat is unbroken.

MAGELLANIC PENGUIN
Size: 2.1 ft (65 cm)

HUMBOLDT PENGUIN
Size: 2 ft (63 cm)

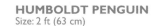

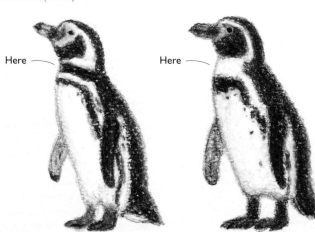

ROCKHOPPER PENGUIN
Size: 22.4 in (57 cm)
Distinctive red bill and eyes, with golden crested feathers that stand straight up. They move by hopping with both feet at the same time.

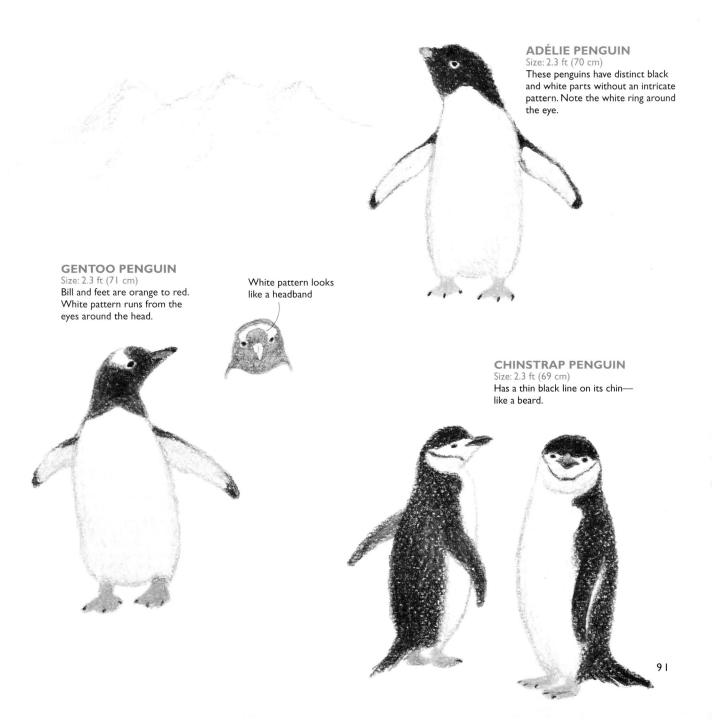

ADÉLIE PENGUIN
Size: 2.3 ft (70 cm)
These penguins have distinct black and white parts without an intricate pattern. Note the white ring around the eye.

GENTOO PENGUIN
Size: 2.3 ft (71 cm)
Bill and feet are orange to red. White pattern runs from the eyes around the head.

White pattern looks like a headband

CHINSTRAP PENGUIN
Size: 2.3 ft (69 cm)
Has a thin black line on its chin—like a beard.

91

part

BRIGHTLY COLORED BIRDS

As if designed by an illustrator, these brightly colored
birds come in every shade and hue. Nature produces
such wonderful color schemes! It's very creative to
draw such beautifully patterned birds with your colored
pencils. Let's draw birds that you will want to add to
your letters or put in a picture frame.

PARAKEET

You get to use beautiful shades of colored pencils when you draw the different kinds of parakeets. It's fun to draw as many gorgeous colors and patterns as you like.

Parakeet's body

Nose

Beak

Two front-facing toes

Two back-facing toes

Species order and family:
Psittaciformes, Psittaculidae

Size: 7–9 in (18–23 cm)

Slightly larger than a sparrow. In the wild, they have a yellow head with black stripes on their body. Intelligent and friendly with humans, they'll even sit on your finger and can learn to speak.

1. Sketch the shape using bluish gray. Draw the eye with black, the nose with light pink, the beak with orangish yellow, and the cheek pattern with deep blue.

2. Color in the face and head using bright yellow. Press down firmly when filling in the front side of the face and shade the color more lightly as you go toward the back of the head.

3. With your lime green pencil, color in the belly and the back. Then with spring green, draw the wing. Create a base that makes it easy to draw the black pattern on the wing.

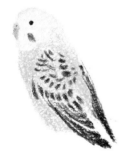

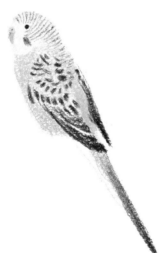

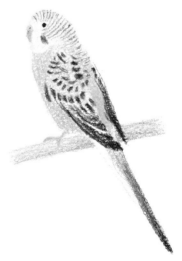

4. Now draw the black pattern on the wing. Layer the entire wing with bright yellow.

5. Add the black pattern on the face. First color the tail in with lime green, then layer over it with deep blue. Next shade the tip with black.

6. Draw the feet in light pink and finish by adding a perch of whatever color you'd like.

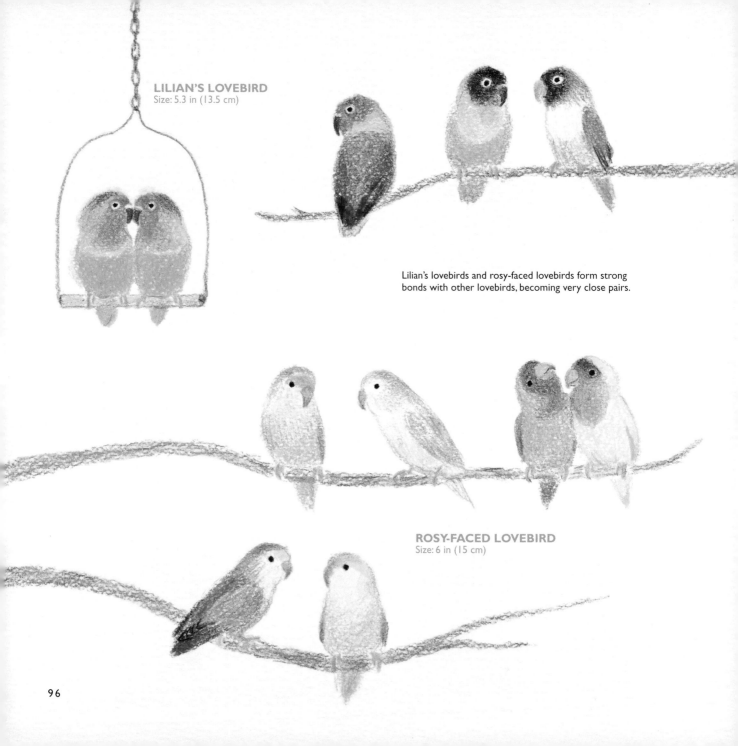

LILIAN'S LOVEBIRD
Size: 5.3 in (13.5 cm)

Lilian's lovebirds and rosy-faced lovebirds form strong bonds with other lovebirds, becoming very close pairs.

ROSY-FACED LOVEBIRD
Size: 6 in (15 cm)

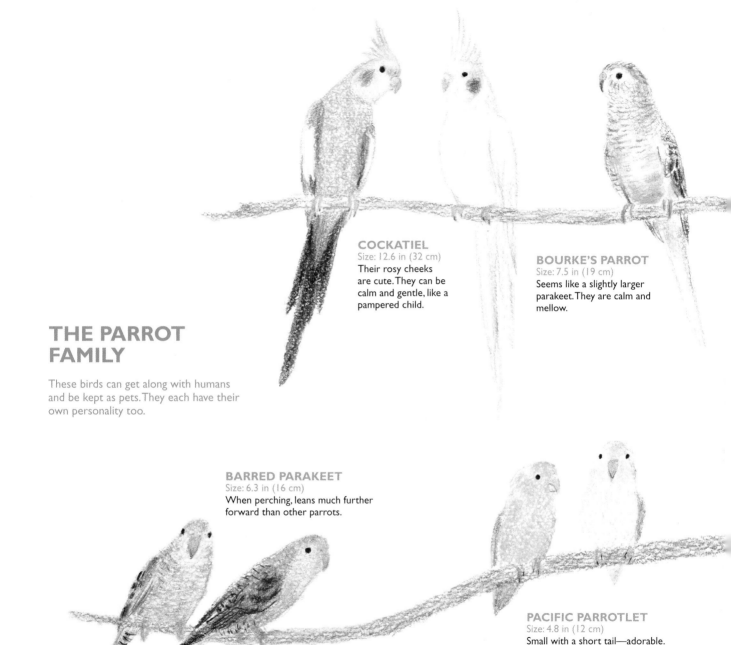

COCKATIEL
Size: 12.6 in (32 cm)
Their rosy cheeks are cute. They can be calm and gentle, like a pampered child.

BOURKE'S PARROT
Size: 7.5 in (19 cm)
Seems like a slightly larger parakeet. They are calm and mellow.

THE PARROT FAMILY

These birds can get along with humans and be kept as pets. They each have their own personality too.

BARRED PARAKEET
Size: 6.3 in (16 cm)
When perching, leans much further forward than other parrots.

PACIFIC PARROTLET
Size: 4.8 in (12 cm)
Small with a short tail—adorable.

AFRICAN GREY PARROT
Size: 13 in (33 cm)

Very intelligent, can even understand human language. Lifespan is approximately 50 years.

Gorgeous red accent color

SULPHUR-CRESTED COCKATOO
Size: 19.7 in (50 cm)

ROSE-BREASTED COCKATOO
Size: 13.8 in (35 cm)

Commonly found in parks throughout Australia.

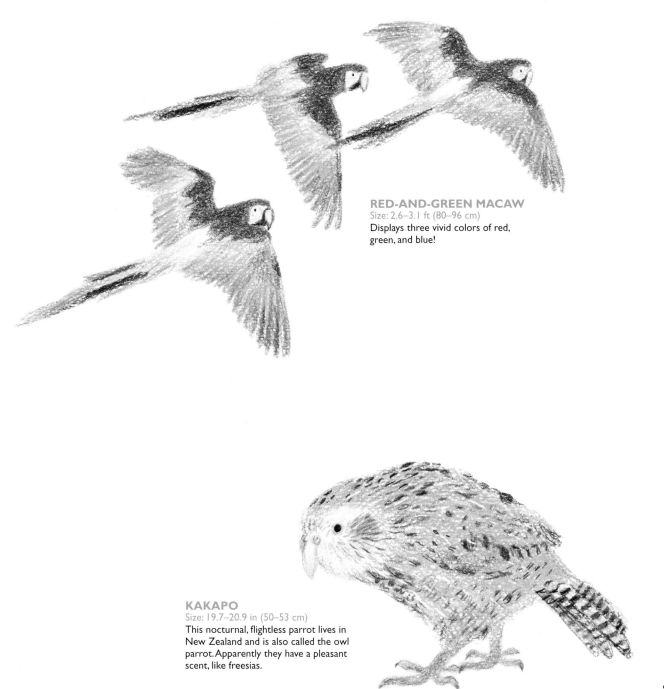

RED-AND-GREEN MACAW
Size: 2.6–3.1 ft (80–96 cm)
Displays three vivid colors of red, green, and blue!

KAKAPO
Size: 19.7–20.9 in (50–53 cm)
This nocturnal, flightless parrot lives in New Zealand and is also called the owl parrot. Apparently they have a pleasant scent, like freesias.

Large bill

Undertail is red

TOUCAN [Toco toucan]

Known as a symbol of South America, with its jet-black body and large orange bill, this striking bird often appears in paintings.

CHESTNUT-MANDIBLED TOUCAN

Species order and family:
Piciformes, Ramphastidae

Size: 12–23.6 in (30–60 cm)

Lives in South America and mainly eats fruit, but occasionally also eats insects and bird eggs. Since it is a tropical bird, its large bill helps to regulate body temperature and keep it from overheating.

RAINBOW-BILLED TOUCAN

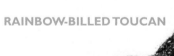

 mustard yellow

 baby blue

dark purple

 dark mauve

light gray

 mustard yellow

 spring green

baby blue

 medium blue

orangish yellow

 reddish orange

 bright red

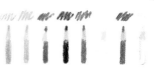

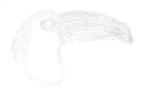

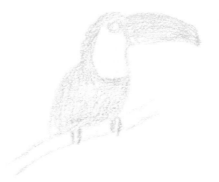

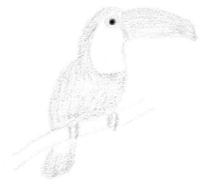

1. Sketch the shape of the face in bluish gray while using deep yellow to draw the bill and the area around the eye.

2. Draw the body in bluish gray, leaving the chest area blank in the shape of a baby's bib.

3. Still using your bluish gray pencil, draw the tail. Switch to royal blue to add the eye, using black for the pupil.

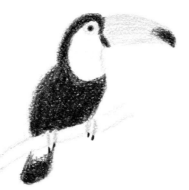

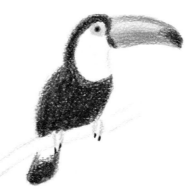

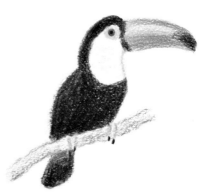

4. Firmly press down your black pencil to color in the dark areas. Then fill in the tip of the bill and draw the claws.

5. With deep red, color in the darker parts of the bill. Use deep yellow to make the entire bill and around the eye a darker color. Go over it once again with bright yellow.

6. Add the red accent color on the undertail using bright red. Fill in the blank parts of the face with off-white. Then add a branch for it to perch on.

101

PEACOCK [Indian peafowl]

Drawing this bird takes patience and perseverance, but they are so beautiful, why not take the challenge? Pay attention to the placement of the round pattern attached to the feathers.

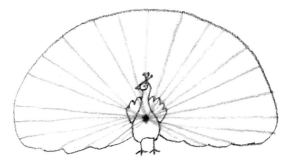

If you follow this order, it will be easier to draw:
(1) First, draw the body in the center.
(2) Draw an outline in the shape of a folding fan.
(3) Draw lines that radiate outward from the center.

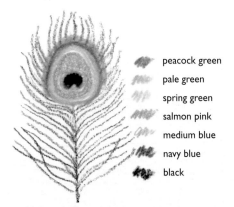

peacock green

pale green

spring green

salmon pink

medium blue

navy blue

black

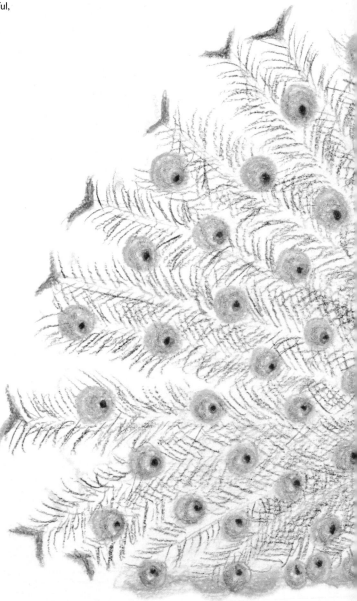

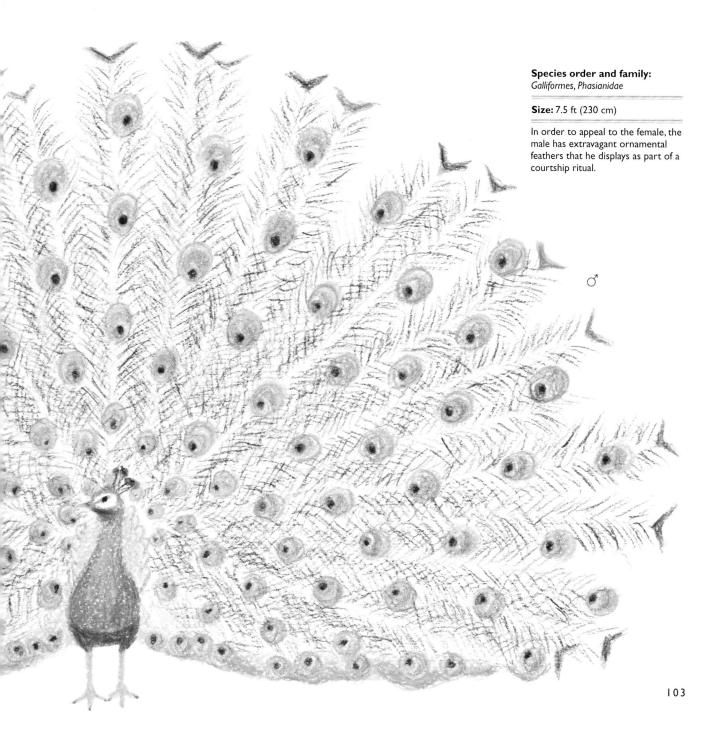

Species order and family:
Galliformes, Phasianidae

Size: 7.5 ft (230 cm)

In order to appeal to the female, the male has extravagant ornamental feathers that he displays as part of a courtship ritual.

♂

HUMMINGBIRD

[Anna's hummingbird]

Just like a honeybee, this tiny bird feeds on the nectar of flowers. There are many species, all of which are gorgeous in color!

GREEN VIOLETEAR

Beak for drinking nectar

Hummingbirds are known for their habit of hovering as they continuously flap their wings.

Species order and family:
Apodiformes, Trochilidae

Size: 2.4–4 in (6–10 cm)

The smallest bird in the world, it lives in North America and inserts its long, thin beak into flowers to drink the nectar.

BEE HUMMINGBIRD

Colored pencils used for hummingbird

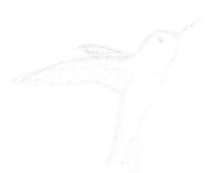

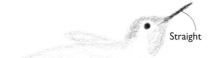
Straight

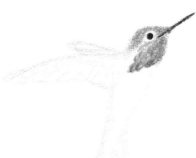

1. Roughly sketch the shape of the body in bluish gray.

2. Draw the beak and the eye with black, and then with moss green, color in the face and head.

3. Add the pattern on the throat using purplish pink. Layer the same color over the moss green face and head. Using fuchsia, draw the scale-like texture of the feathers on the throat.

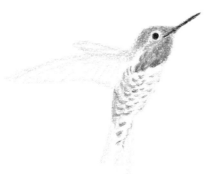

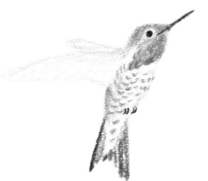

4. Color in the base of the wings and the body with chartreuse. Without filling in the belly, draw the scale-like texture of the feathers.

5. Using dark brown, add texture to the feathers over the entire body. With your chartreuse pencil, draw the tail, filling in its darker areas with midnight gray. Add the feet in black.

6. Color in all of the wings with dark brown and midnight gray, then fill in the tail with bluish gray.

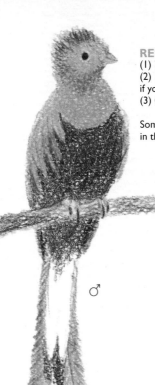

RESPLENDENT QUETZAL
(1) *Trogoniformes, Trogonidae*
(2) 13.8 in (35 cm) (3–3.9 ft [90-120 cm] if you include the length of the tail)
(3) Central America

Some say this is the most beautiful bird in the world.

♂

Long ornamental tail feathers

NORTHERN CARMINE BEE-EATER
(1) *Coraciiformes, Meropidae*
(2) 13.8 in (35 cm) (3) Africa

Vibrant red color with aqua on the head and belly.

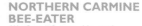

GORGEOUS BIRDS FROM AROUND THE WORLD

(1) Order • Family (2) Size (3) Where they live

Pale but gorgeous hues

FAIRY PITTA
(1) *Passeriformes, Pittidae*
(2) 7 in (18 cm)
(3) Southeast Asia

Lustrous green color

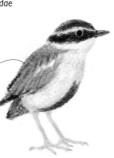

LILAC-BREASTED ROLLER
(1) *Coraciiformes, Coraciidae*
(2) 15.7 in (40 cm) (3) Southern Africa

* Symbols for male and female indicate birds that differ in color between the sexes.

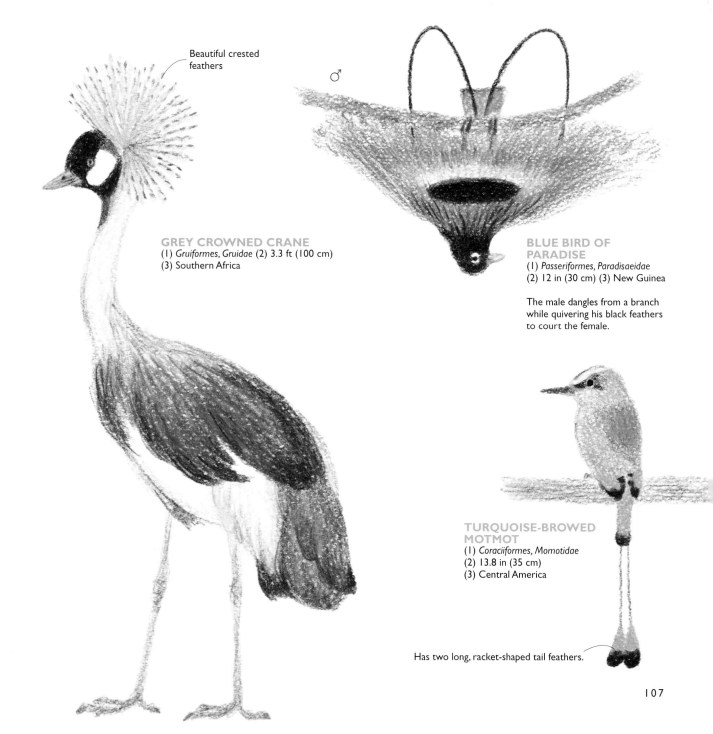

Beautiful crested
feathers

GREY CROWNED CRANE
(1) *Gruiformes, Gruidae* (2) 3.3 ft (100 cm)
(3) Southern Africa

♂

**BLUE BIRD OF
PARADISE**
(1) *Passeriformes, Paradisaeidae*
(2) 12 in (30 cm) (3) New Guinea

The male dangles from a branch
while quivering his black feathers
to court the female.

**TURQUOISE-BROWED
MOTMOT**
(1) *Coraciiformes, Momotidae*
(2) 13.8 in (35 cm)
(3) Central America

Has two long, racket-shaped tail feathers.

107

BIRD ENCOUNTERS

If you have food for them, you will be swarmed with parakeets before you know it.

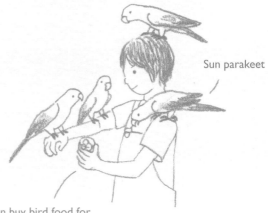

Sun parakeet

In the big greenhouse at Kakegawa Kachoen Flower and Bird Park, there are so many parakeets!

You can buy bird food for ¥100 (about $15 USD).

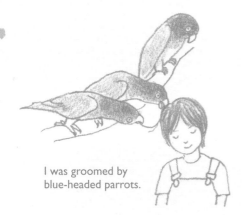

I was groomed by blue-headed parrots.

Popo, the northern white-faced owl

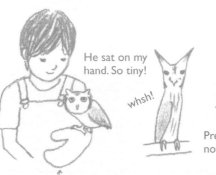

He sat on my hand. So tiny!

whsh!

Pretending he's not there.

Owls' talons are sharp, so you need to wear a glove.

When a threat approaches, they make themselves thin like this so that they look like something else.

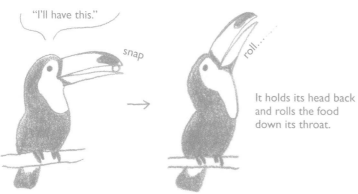

"I'll have this."

snap

roll......

It holds its head back and rolls the food down its throat.

Toucans have a very interesting way of eating.

At the emu feeding corner at Fuji Kachoen Flower and Bird Park

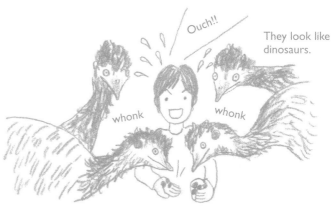

Ouch!!

They look like dinosaurs.

whonk

whonk

All of a sudden, I was surrounded on all sides. Before I knew it, they were biting me. And it hurt! But I got used to it and did it a few more times.

There were also emu chicks.

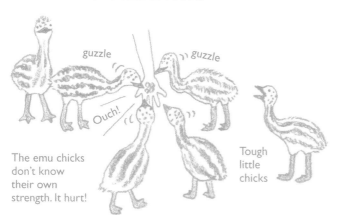

guzzle

guzzle

Ouch!

The emu chicks don't know their own strength. It hurt!

Tough little chicks

Kakegawa Kachoen Flower and Bird Park
"This is where I encountered parakeets, toucans, and Popo!" Kakegawa City, Shizuoka Prefecture, Japan. 0537-62-6363

Fuji Kachoen Flower and Bird Park
"This is where I fed the emus!"
Fujinomiya City, Shizuoka Prefecture, Japan. 0544-52-0880

Ai Akikusa

A picture book author, illustrator, and 3D molding artist, Ai Akikusa graduated from the Department of Graphic Design, Tama Art University. After working at the Nakamori Design Office, she is now a freelance artist. She is also the author of *Drawing Cute Animals in Colored Pencil* (Quarry Books, 2014).

Also available from Quarry Books

Drawing Cute Animals
in Colored Pencil
978-1-59253-936-9

Illustration School:
Let's Draw Magical Color
978-1-59253-917-8

20 Ways to Draw Everything
978-1-63159-267-6

Draw 500 Amazing Sea Creatures
978-1-63159-254-6